POSTCARD HISTORY SERIES

Garrett County

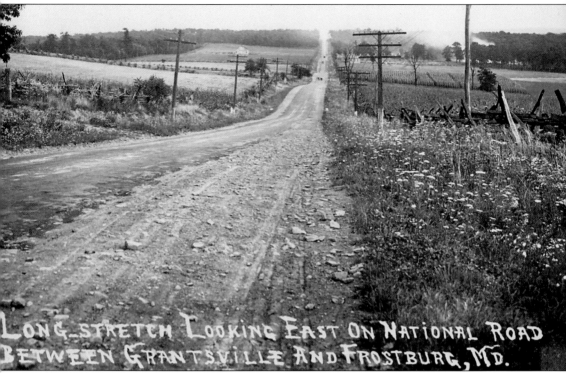

LONG STRETCH LOOKING EAST ON NATIONAL ROAD BETWEEN GRANTSVILLE AND FROSTBURG, MD.

In 1806, Congress authorized construction of the Cumberland Road to connect the populated east and "navigable waters emptying into the Atlantic" to the Ohio River. Construction of the 132-mile road began at Cumberland, Maryland, in 1811 and was completed to the Ohio River at Wheeling, Virginia (now West Virginia), by 1818–1819. The "National Road," as it became known, was the nation's first federally funded and designed interstate highway. For the most part, the National Road lies just southeast of the old Braddock Road, the route taken by Gen. Edward Braddock and George Washington, who served as an aide-de-camp on Braddock's staff, on their ill-fated march from Fort Cumberland to Fort Duquesne (now Pittsburgh) in 1755 at the outbreak of the French and Indian War. This early-20th-century scene depicts Long Stretch between Frostburg and Grantsville, looking east on the National Road. (L. J. Beachy Photograph.)

ON THE FRONT COVER: The Garrett County Courthouse was constructed between 1907 and 1908 and stands atop what was once popularly referred to as "Courthouse Hill." The building underwent substantial remodeling in the late 1970s. The cover photograph is postmarked 1909 and was sent to Charles Miller of Boonville, Missouri. The sender writes, "Dear Daddy: Betsy said she wanted granddaddy to know that she has *one tooth* and another almost thru. Wish you were here with me. Love, Ellen."

ON THE BACK COVER: Installation of the Deep Creek Bridge followed the damming of Deep Creek Lake in 1925. In 1986–1987, a new bridge was constructed to carry U.S. Route 219 across the lake. The old Deep Creek Lake Bridge, as shown here in a photograph postmarked July 16, 1937, was then removed. The sender writes to her friend in Washington, D.C., "Dear Gertrude. We have been having a fine time up here. The weather has been very much cooler than it was in Colonial Village when we left. Love to all. Affectionately, Aunt Sue."

POSTCARD HISTORY SERIES

Garrett County

Albert L. Feldstein

ARCADIA
PUBLISHING

Published by Arcadia Publishing
Charleston, South Carolina

Printed in the United States of America

Library of Congress Catalog Card Number: 2006920983

For all general information contact Arcadia Publishing at:
Telephone 843-853-2070
Fax 843-853-0044
E-mail sales@arcadiapublishing.com
For customer service and orders:
Toll-Free 1-888-313-2665

Visit us on the Internet at www.arcadiapublishing.com

This book is dedicated to my wife, Angela; daughters, Natasha and Josinda; and stepson, Michael Mulligan. It is also dedicated to the good citizens of Garrett County and all those people who have supported and shared in my love of history throughout the years.

CONTENTS

ACKNOWLEDGMENTS

There are many people who in many ways helped me with this work. I acknowledge my fellow historians: the Reverend John A. Grant, Kevin E. Callis, Robert E. Boal, Francis Zumbrun, and Bob Bantz. I am deeply grateful to Dale Morrow for permission to use the postcards and photographs of his late father, Ruthvan W. Morrow Jr., and to Maxine Beachy Broadwater for permission to use the postcards created by her uncle, Leo J. Beachy. Assistance provided by Charles G. "Bud" Railey, Mike and Sue McLuckie, John Rafferty, Lynn Workmeister, Gary and Bill Warn, Sybil Ours, Steven Amoroso, and Vicki Day is also noted.

Most importantly, I must recognize those local photographers and publishers who over the past 100 years created, produced, and preserved for posterity the historic images of Garrett County used in this publication: Ruthvan W. Morrow Jr., Leo J. Beachy, Ernest K. Weller, Ronald L. Andrews, Joseph E. Revell, C. E. Gerkins, Stewart Photo, E. Bumgartner, W. A. Gonder Confectioner of Oakland, the Journal Stationery Store of Oakland, Neff Novelty Company of Cumberland, Hamill's Stationery and Book Store of Oakland, M. Leighton of Mountain Lake Park, L. A. Rudisill of Mountain Lake Park, G. E. Pearce Drug of Frostburg, Gilbert's Studio of Frostburg, and the J. W. Jackson Company of Oakland.

In the interest of full disclosure, there are a handful of instances where the photographs are not postcards, but pictures taken by myself. I felt these needed to be included to incorporate important subjects of interest of which I did not have a postcard image. These are identified as "Author Photograph." I also accept full responsibility for any omissions or errors.

Since 1980, I have published 27 books, prints, and videotapes depicting the history of Allegany, Garrett, and Washington Counties, as well as nearby West Virginia. These works have focused upon such varied topics as historic postcards, newspapers, floods, grave sites, coal mining, railroads, community histories, and tour guides to historic sites. My latest effort is a political history poster entitled "Buttons of the Cause, 1960–2003: The Events, the People, the Organizations, the Issues," which is being marketed nationally and can be viewed at my Web site, http://www. buttonsofthecause.com. Throughout this entire period, my wife, Angela, has been at my side. She has provided me understanding, support, and above all, patience. To her I am most indebted.

INTRODUCTION

In January 1872, a number of residents from the western portion of Allegany County sent a petition to the state legislature requesting the creation of a new county. Advocates of the new county cited as their main reasons for this initiative the substantial distance from far western Maryland to the existing county seat in Cumberland, greater representation in the state's general assembly, greater opportunities for local tax revenue, and more appropriate expenditures of public funds. Two possible names were proposed for the new county, Garrett and Glade. Acting in compliance with this petition, a new county was established by the Maryland State Legislature on April 1, 1872. Named after John Work Garrett (1820–1884), then-president of the Baltimore and Ohio Railroad, Garrett County was formed from the western section of Allegany County and has the distinction of being the last county created within the state of Maryland.

It was a constitutional requirement, however, that the final ratification of the county's creation be left up to the qualified voters of the territory. The question concerning the creation of a new county, as well as the people's choice for county seat, were both voted on in the November 4, 1872, general election. Voters overwhelmingly approved creation of the new county by a vote of 1,297 to 405. The popular choice of the electorate for the county seat was Oakland, which won out over rivals Grantsville and McHenry's Glades, the former by only 63 votes. On December 4, 1872, Maryland governor William Pinkney Whyte proclaimed that the extreme western triangle of the state "has become and is now constituted as a new county, to be called 'Garrett County.' " In 1880, the first Garrett County census showed a population of 12,175 people.

The county would owe much of its eventual development to the building of the Baltimore and Ohio Railroad through its mountains in 1851–1852. Earlier development and settlements were the result of such transportation breakthroughs as the building of this nation's first federally funded and constructed highway, the National Road, from Cumberland, Maryland, to Wheeling, West Virginia, between the years 1811 and 1819. Over 20 miles of this 132-mile road pass through the northern portion of present-day Garrett County.

This book seeks to provide an in-depth sampling within the space permitted of the numerous scenes and sites—many of which have long since disappeared—that portray the history and heritage of Garrett County. One thing I tried to do differently from previous works was to incorporate as many of the messages as I could from the back of the postcards. They're fun to read.

I hope you, the citizens and friends of Garrett County, enjoy viewing these postcards as much as I have enjoyed compiling them for you.

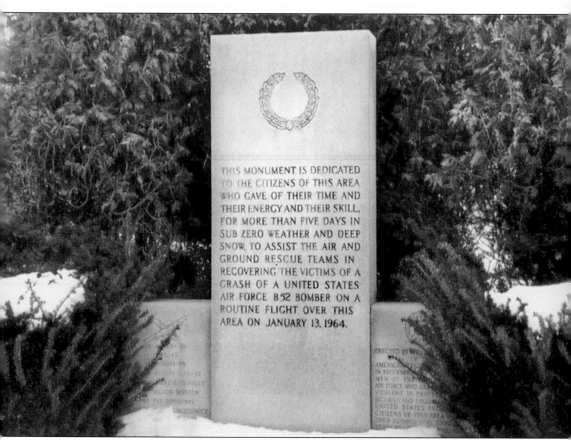

THIS MONUMENT IS DEDICATED
TO THE CITIZENS OF THIS AREA
WHO GAVE OF THEIR TIME AND
THEIR ENERGY AND THEIR SKILL,
FOR MORE THAN FIVE DAYS IN
SUB ZERO WEATHER AND DEEP
SNOW, TO ASSIST THE AIR AND
GROUND RESCUE TEAMS IN
RECOVERING THE VICTIMS OF A
CRASH OF A UNITED STATES
AIR FORCE B-52 BOMBER ON A
ROUTINE FLIGHT OVER THIS
AREA ON JANUARY 13, 1964.

In the pre-dawn hours of January 13, 1964, a United States Air Force B-52 bomber carrying two 24-megaton nuclear bombs and five crew members crashed in Garrett County at the foot of a snow-swept Big Savage Mountain. Severe turbulence resulting in the tail being ripped off led to the order to bail out. It was about 4:00 p.m. when the pilot, Maj. Thomas McCormick, showed up at a Grantsville farm. Maj. Robert Townley was unable to clear the plane and died in the crash. Capt. Parker Peedin was found alive the next day. Two others, Maj. Robert Payne and S/Sgt. Melvin Wooten, perished in the sub-zero weather. For five days and nights volunteers searched for missing members of the crew. This monument, commissioned by the Air Force and placed by Mountain District, American Legion on U.S. Route 40 east of Grantsville, pays tribute and honors the bomber crew and those area citizens who assisted the military air and ground rescue teams in recovering the crash victims. (Author Photograph.)

One

OAKLAND
The Wilderness Shall Smile

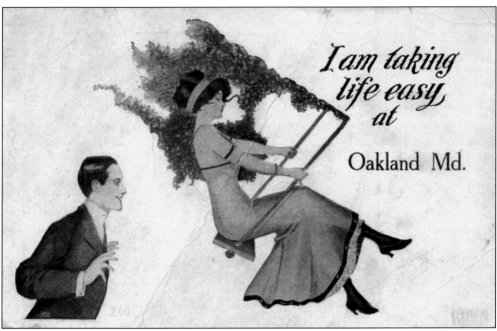

"I'm taking life easy at Oakland, Maryland." Oakland had settlements dating from the early 19th century, when the land was first patented and named the Wilderness Shall Smile. Among these early settlers was Isaac McCarty, who owned much of the land that later became Oakland and is considered its founder. Isaac subdivided and laid out the town in 1849, two years before the Baltimore and Ohio (B&O) Railroad's arrival in 1851. Suggestions for the official town name included "McCarty's Mill," "Slab Town," and "Yough Glades," which was what the community was popularly known as for some years. Isaac McCarty's daughter, Ingabe, finally suggested "Oakland." Oakland was incorporated by the state legislature in 1862 and voted upon as the county seat in the election of November 4, 1872. The back of this postcard dated February 17, 1915, reads, "Dear Miss Laura, How are you now? Hope you arrived home safe. Would you care to correspond with me? Please answer. Lloyd."

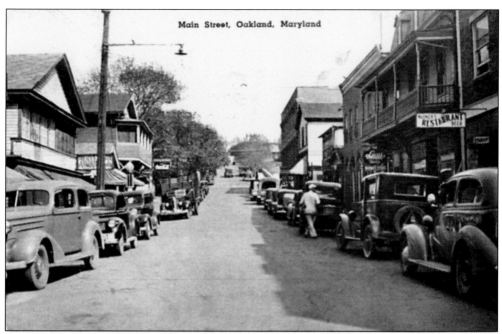

This is Main Street in Oakland from a postcard dated 1943. The sender writes, "Dear Maril and Will. The air up here is wonderful. We sleep under two blankets every night. I feel much better than I did before. Sister Mary is up with me and she sends her love. Love, Aunt Lizzie and Mary." Note Warnick's Restaurant and Brown's Store on the right.

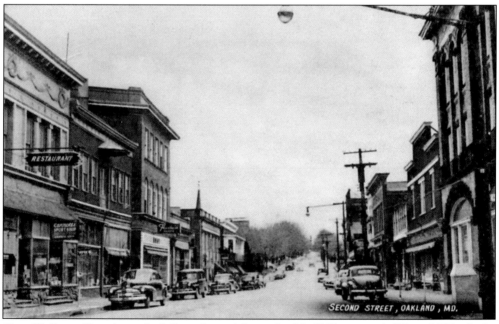

Carroll's Sport Shop is on the left on Second Street in this 1953 postcard. "Dear Mildred, the Doctor thought it would be nice to see the fall foliage in the mountains. The ride was beautiful. We went to the falls today which was scant for lack of rain. I hope you are feeling yourself. Love, Virginia."

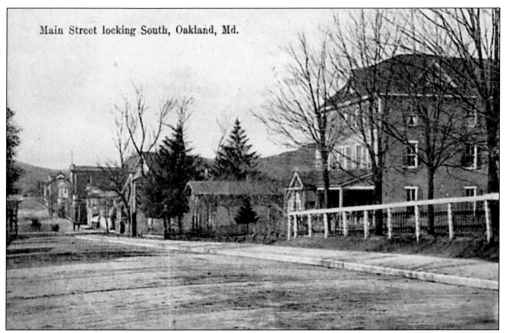

This earlier view looks south on Main Street (now Second Street) from a postcard dated November 17, 1916. The sender writes, "Dear Mother and all, I got here all ok and found them all well. I'm better for that. It's cold now. Hope you are well and love from all, Billie."

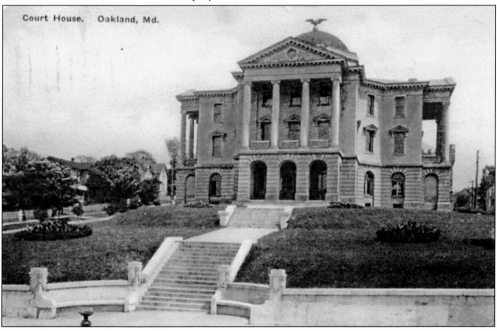

The Garrett County Courthouse was designed by New York architect J. Riley Gordon and erected between 1907 and 1908. The courthouse actually had its cornerstone laying ceremony on October 15, 1907, and it is the second courthouse to have served the county. This 1920 postcard reads, "Dear Helen: You get all your dishes washed in time? Write me a few lines and tell me how all of Painesville [Ohio] is getting along. Having a dandy time here. Love, Peg."

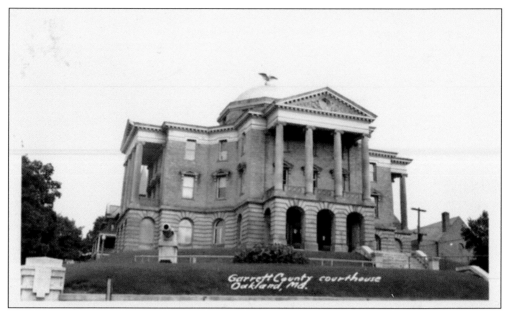

Designed in a Neoclassical Renaissance Revival style, major alterations and additions were made upon the Garrett County Courthouse between 1977 and 1979, significantly changing its historic appearance. The writer of this postcard in December 1947 writes, "Dear Irene. No deer yet. It is hailing so hard up here now, I dare not attempt the roads. Love, Morton." The site was commonly referred to as Courthouse Hill.

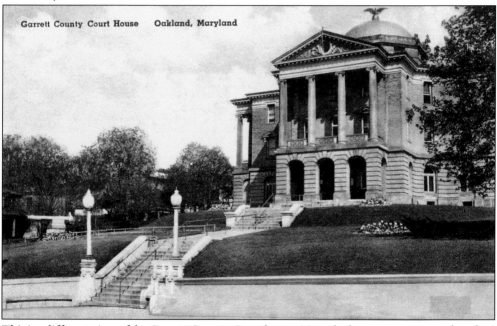

Garrett County Court House Oakland, Maryland

This is a different view of the Garrett County Courthouse. Note the lampposts, concrete benches, wall, and steps. The sender writes, "Dear Bertha. Arrived in Oakland at 3:33 p.m. Made fine connections all the way. Had 14 minutes to change stations in Martinsburg but took a cab and got through ok. I am feeling well, but real tired. Was only off the train about 25 minutes until arriving in Oakland. Your Friend, Nellie."

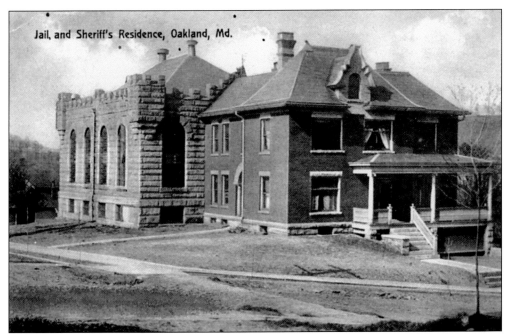

Jail, and Sheriff's Residence, Oakland, Md.

Above is a 1913 depiction of the Garrett County Jail and sheriff's office, which originally included the sheriff's residence and was designed by the architectural firm of Holmboe and Lafferty from Clarksburg, West Virginia. The facilities were constructed in 1905 at the cost of $35,981. The scene below depicts where the Garrett County Jail and sheriff's office stood at the rear of the courthouse. The sheriff's office and jail were both demolished during the courthouse renovations in the late 1970s. The back reads, "Miss Fanny: Have been to Oakland often but never stopped over for any length of time. Pretty good place on the outside."

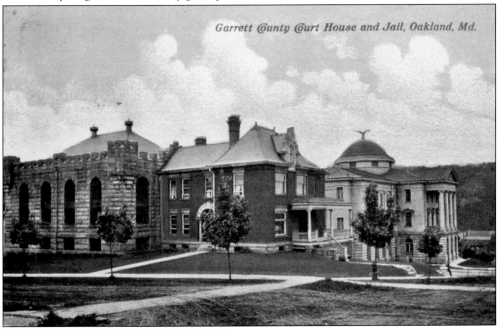

Garrett County Court House and Jail, Oakland, Md.

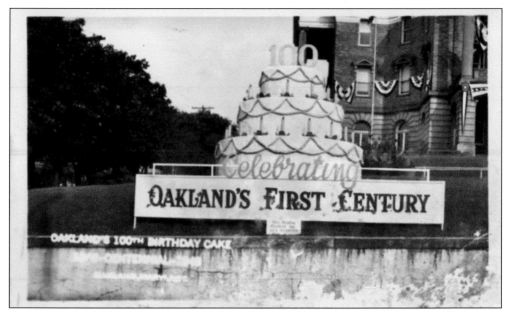

The postcard is from Oakland's 1949 centennial celebration. Aza Stanton, with assistance provided by Thurl Tower, designed and created this birthday cake on the Garrett County Courthouse lawn celebrating the City of Oakland's 100th birthday. The cake took three weeks to build, stood over 12 feet high, and consisted of 700 feet of lumber, 250 feet of chicken wire, a ton of newspaper for papier-mâché, and 25 gallons of paint.

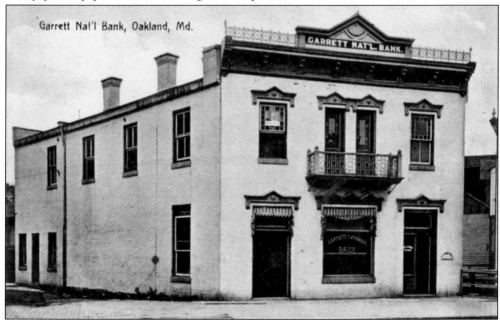

This 1914 postcard depicts the Garrett National Bank building. The bank was originally organized in 1888 by a group of Oakland businessmen under the name the Garrett County Bank of Oakland. This was the first bank established in Garrett County. In 1903, a charter converting this institution to the Garrett National Bank of Oakland was issued. The original bank building was constructed on Second Street and opened for business on November 14, 1888.

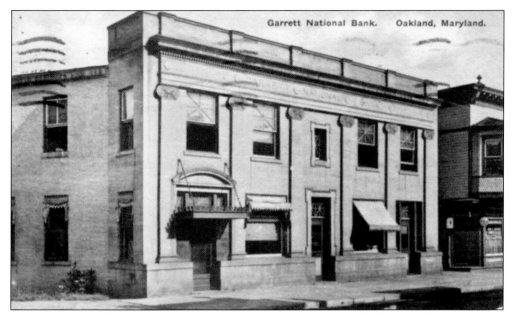

The Garrett National Bank's second floor initially served as an apartment for bank officials. The bank building, as seen here in a postcard dated 1940, was later enlarged and substantially modernized. Later known as the Professional Building, the building was purchased in 1996 and is now home to the Garrett County Historical Society. The sender of this card notes the train was late but the fishing is real good.

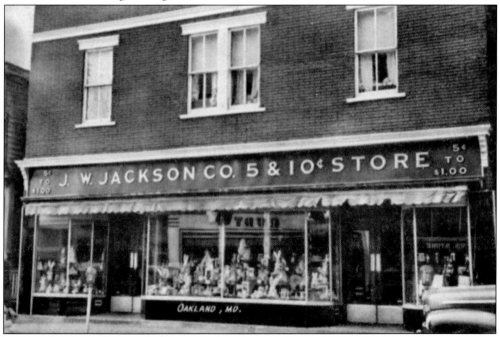

In 1935, this building was purchased by John W. Jackson, remodeled, and named the J. W. Jackson Company, 5 and 10 Cents Store, where everything was 5¢ to a dollar. The Jackson store, seen here in about 1950 at its location on the corner of Second and Green Streets, was destroyed by a fire in 1968.

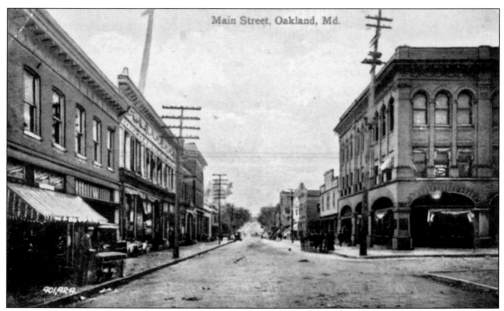

The scene above is Main Street, Oakland, about 1907. The building on the right, at the corner of Second and Alder Streets, is the First National Bank of Oakland. This bank received its charter on November 15, 1900. The bank building depicted in this postcard was constructed in 1903 and opened for business in November of that year. On the left is the Bon-Ton and Confection Shop of W. A. Gonder. The back of this postcard reads, "Am showing Papa the town. Had him at work in the oats for a while today."

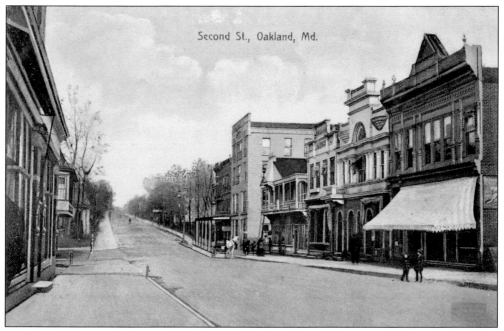

This pleasant postcard view portrays Second Street in Oakland during the early 20th century. Note the old J. M. Davis Hardware store, third from the right, which sold everything from stoves and tinware to harnesses.

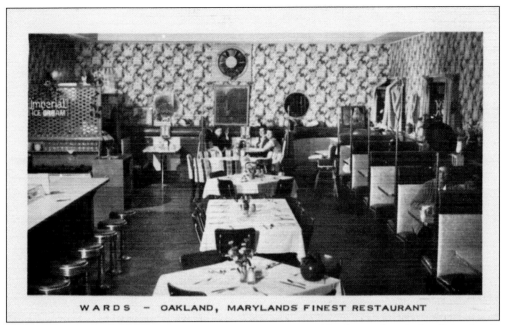

As seen in this view from about 1952, Ward's Restaurant in Oakland was advertised as "Maryland's Finest Restaurant." The advertisement on the back notes that Ward's is located "in the summer resort area in the mountains of Maryland, catering to people who enjoy really good food."

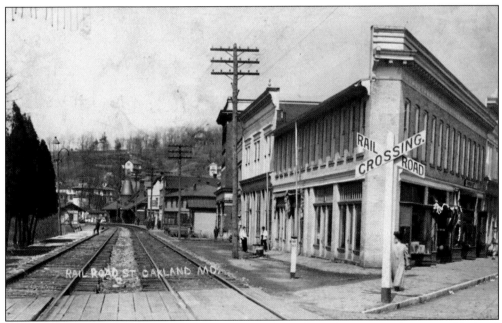

Above is a wonderful view of Railroad Street from the early 20th century. The postcard is dated 1920. The Gonder Building, depicted on the right, was destroyed by a fire in February 1994. A new Gonder Building was constructed on the site the following year. Those are the tracks of the B&O Railroad in the foreground.

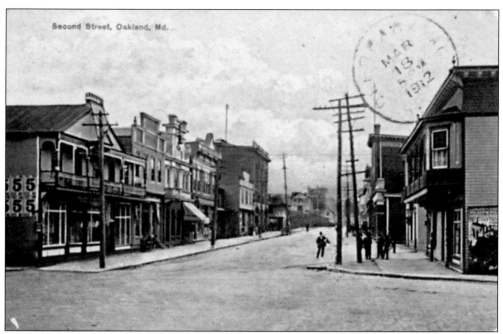

This is Second Street as it appeared in a view postmarked March 16, 1912. The sender writes, "Dear Cora, Glad to hear from you. I got the sample bottle of cough medicine today. Thank you for thinking of me and my old cough. We have lots of sickness in our family this winter. Best Wishes, Mother."

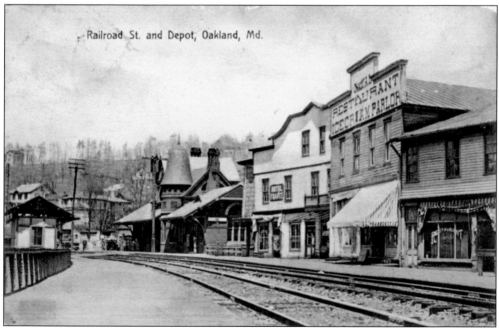

This is another view of Railroad Street, postmarked 1910. Guests staying at the Hotel Frantz, depicted in the middle, could go next door for a fine meal in the restaurant or have dessert at the ice cream parlor while waiting for their train at the Oakland depot, which stands in the background. B&O Railroad passenger service ended in Oakland in 1971.

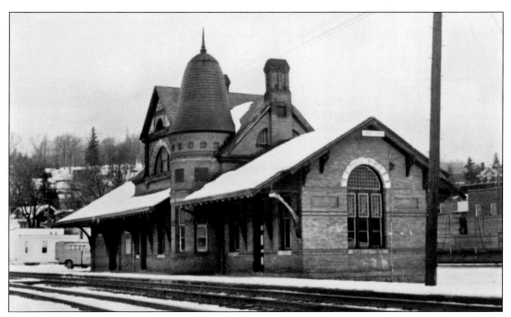

The B&O Railroad established its first station in Oakland upon the railroad's arrival in 1851. The station that stands in Oakland today was built by the B&O Railroad in 1884 and was designed by the Baltimore architectural firm of Baldwin and Pennington, who between 1870 and 1896 were hired by the B&O Railroad to design most of its stations. The B&O Railroad Station in Oakland represents a superior example of the Queen Anne architectural style. (Ronald L. Andrews Photograph.)

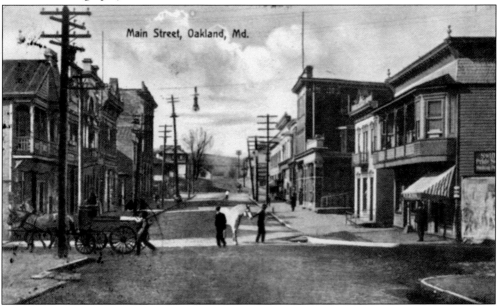

This is Main Street (later Second Street) from a postcard dated 1911. The back reads, "Less than two mile to Mt. Lake Park. All is well. From Pa." The building on the right, at the corner of Liberty Street, was destroyed by fire in January 1999. The site is now home to Dailey's Park. The building to its immediate right is the old Garrett National Bank, now the Garrett County Historical Society. Firefighters were able to save that site from damage.

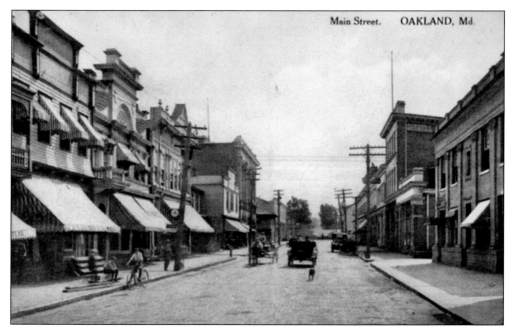

The building on the right is the newer, substantially remodeled Garrett National Bank, and beyond that is the Offutt Store, which at that time was advertised as the "largest general merchandise store in Western Maryland." The Offutt Building was constructed about 1899 and remains standing on Main Street (now Second Street) today. Through the years, it has been known as Fraley's Store, the Coffman Fisher Company, and Rudy's Store.

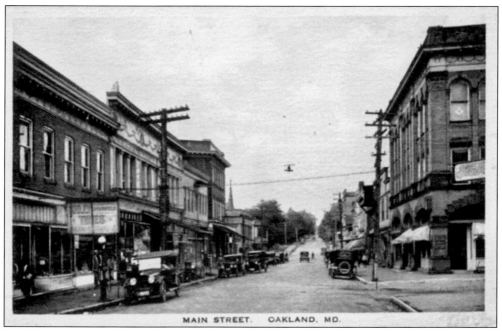

MAIN STREET. OAKLAND, MD.

Depicted on the left of this Main Street photograph is the Oakland Auto Supply Company, featuring Kelly Springfield Tires. On the right is the First National Bank of Oakland building, which was constructed and opened for business in 1903.

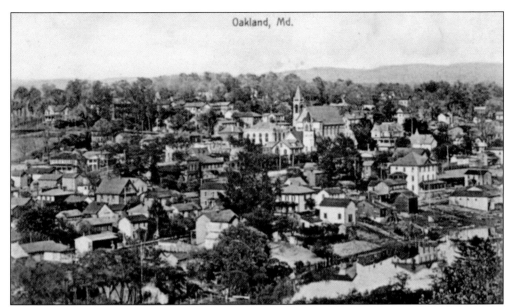

Oakland, Md.

The sender of this birds-eye view of Oakland writes, "Dear Bub, I am spending a few days with Will on the Allegheny Mountains where he is working. Love to all from Irene." Though postmarked 1909, the photograph seems to have been taken before the completion of the Garrett County Courthouse in 1908. Its construction is vaguely discernible. The postcard also depicts the towering St. Peter's Roman Catholic Church and the former St. Paul's Methodist.

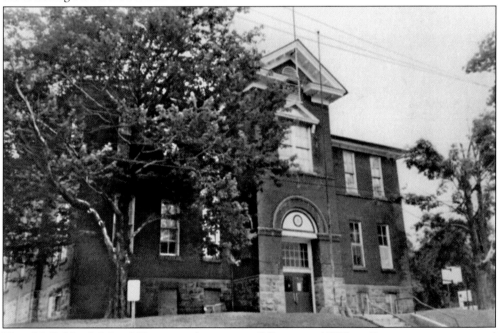

The old Oakland School House, at the corner of Centre and Wilson Streets, was constructed in 1894–1895. The school was built at a cost of $12,512.45 with funds believed to be originally earmarked for teaching. This was due to a school construction bond issue being voted down; as a result the school term that year ended after just six weeks. In 1922, this school building was badly damaged by fire but was soon rebuilt and remodeled. (Author Photograph.)

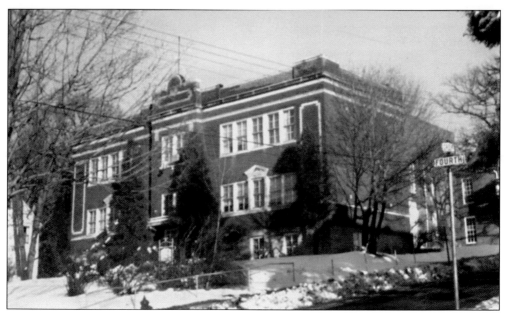

In 1910, high school classes were relocated from the old schoolhouse to the former Garrett County Courthouse, which had been built in 1877. Several years later, in 1918, the new Oakland High School, seen here in 1975, was constructed and incorporated the former courthouse. The last class graduated from here in 1952. This building served as the Garrett County Board of Education and was razed shortly after the board's 2001 relocation into a new facility. (Ronald L. Andrews Photograph.)

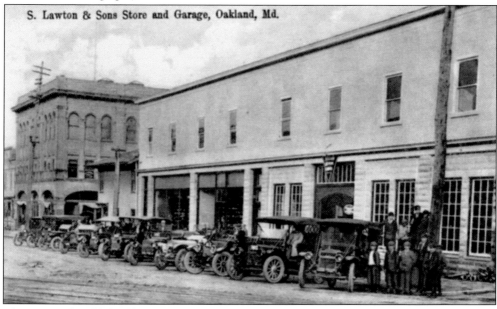

This postcard, published by the Journal Stationery Store in Oakland, depicts the S. Lawton and Sons Store and Garage on Second Street at Oak Street. The Lawton building was also noted for housing a theater on the second floor. Destroyed by fire in the 1940s, the site was from 1946 the home of Englander's Pharmacy and is now occupied by an antique and craft store as well as Englander's soda fountain and restaurant.

22

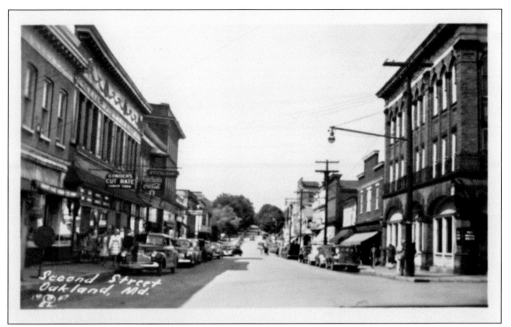

This is Second Street as it appeared in 1947. On the left is featured Gonder's Cut Rate Store, Lunch, and Soda Shop, while on the right is the First National Bank.

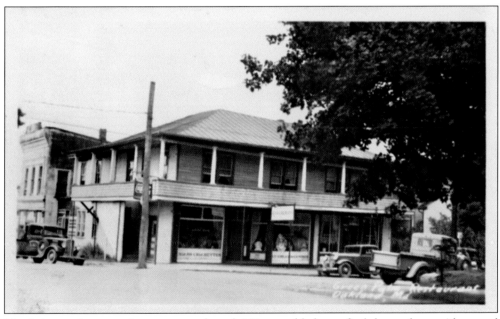

Need cigars, cigarettes, ice-cream, and candy? You could always find them, along with a good meal, at the Green Palm Restaurant. This depiction of the Green Palm Restaurant is most likely from the mid-1930s. The restaurant was located at the corner of Third and Oak Streets and owned by Victoria Ingram. The wooden structure was razed in 1949 and replaced by a brick building that housed the A&P market.

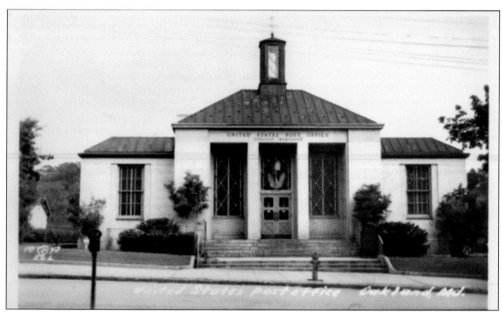

In 1939, land was acquired for a new U.S. Post Office facility on Second Street in Oakland. Construction began in 1940, and the post office was open for business in 1941. Built at cost of $80,000, the edifice, as seen in this 1947 photograph, is typical of the classically inspired buildings erected by the federal government during this period.

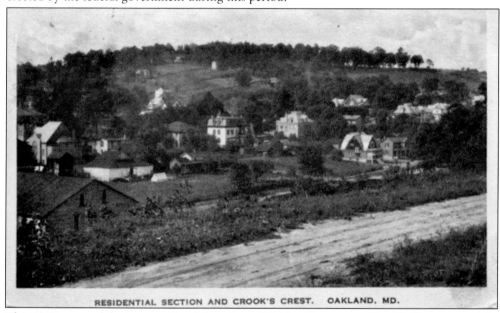

RESIDENTIAL SECTION AND CROOK'S CREST. OAKLAND, MD.

This 1923 postcard depicts a residential section of Oakland known as Crook's Crest, named for the Civil War Union general George Crook. Crook gained later fame in the Western campaigns against Sitting Bull, Crazy Horse, and Geronimo. Crook died in 1890 while Crook's Crest was under construction and was buried in Oakland. Attendees included William "Buffalo Bill" Cody and then-congressman William McKinley. The body was later relocated to Arlington National Cemetery. Mary Crook, a native of the area, went on to reside at Crook's Crest for some years.

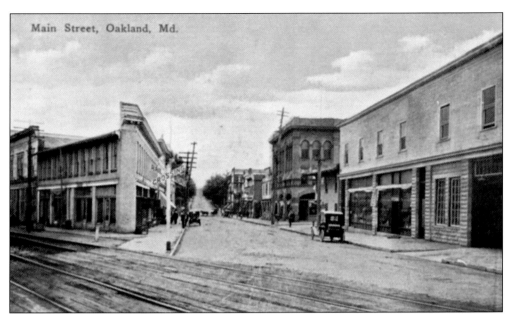

Main Street, Oakland, Md.

This is Main Street much as it appeared about 1913. Note the Gonder Building on the left. On the right is the S. Lawton and Sons Store and Garage, "Plumbers, Steam and Gas Fitters, Coal and Gas, Jewell Stoves, Ranges, and Heaters." S. Lawton and Sons was a member of the Association of Master Plumbers of Maryland.

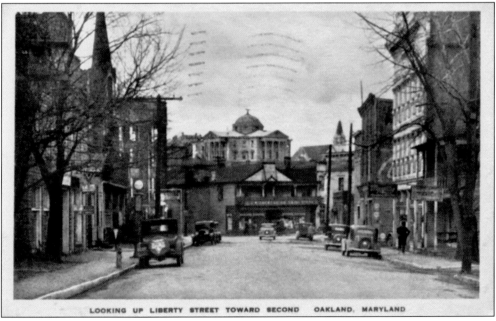

LOOKING UP LIBERTY STREET TOWARD SECOND OAKLAND, MARYLAND

This is Liberty Street looking toward Second Street about 1937. Note the J. W. Jackson Store and the Garrett County Courthouse. The building on the right, with a Maytag sign hanging in front, was the A. D. Naylor Building, which was constructed on Liberty Street in 1899. It was destroyed by fire in 1975. The Naylor Company has its genesis in 1884, when Alonzo Drake Naylor established a blacksmith shop in Oakland. A new Naylor hardware store was built on Third Street and opened in 1977.

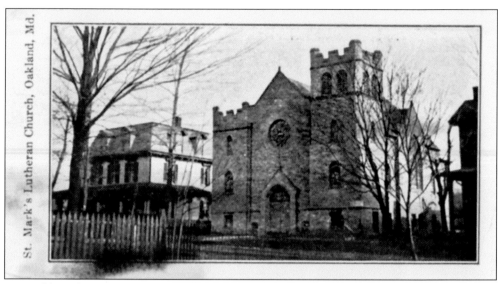

St. Mark's Lutheran Church, Oakland, Md.

St. Mark's Lutheran Church, as depicted in this 1909 view, was built in 1906 on Second Street. It replaced an earlier structure at the corner of Third and Alder Streets that was destroyed by fire in 1905. Zadie Browning's Boarding House appears on the left. The sender writes, "Dear Marie: We both wish you ever so much joy. With love to all, your friend, Charles."

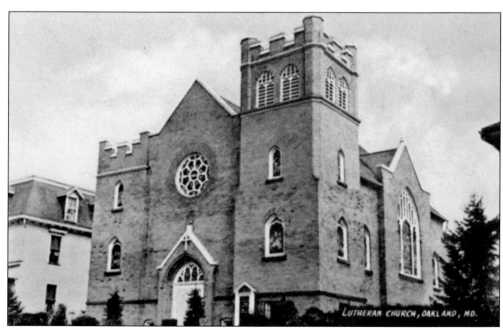

LUTHERAN CHURCH, OAKLAND, MD.

This is another view of the St. Mark's Lutheran Church. The church building and Zadie Browning's Boarding House were both razed about 1975 with the construction of the current St. Mark's on the corner, the approximate site of the former boarding house.

This 1908 postcard depicts the former St. Paul's Methodist Church, which was built in 1891 at a cost of $7,700 and which stood on the site of the present church parsonage. Part of this building was razed and the main portion relocated to the corner of Oak and Fourth Streets.

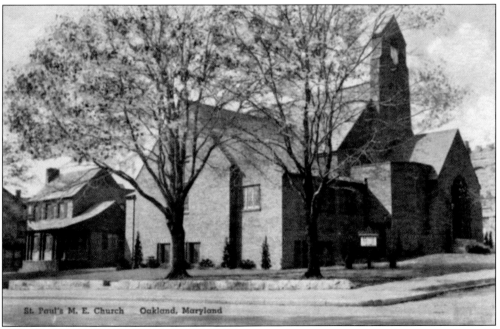

As seen here, the church was remodeled, enlarged, and incorporated into the present St. Paul's Methodist Church. St. Paul's was dedicated on April 5, 1936. The sender of this September 7, 1944, postcard writes, "We are under fur blankets and the weather is fine. Will be home next Tuesday. Regards, Lottie."

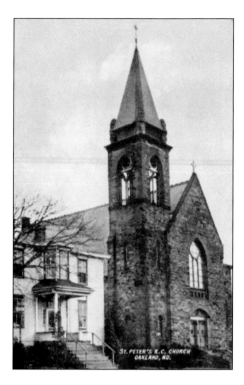

This postcard depicts St. Peter's the Apostle Roman Catholic Church on Fourth Street. Construction on the stone St. Peter's church was begun in 1901 with the formal dedication taking place on September 6, 1903. This replaced an earlier church, which was dedicated on June 29, 1852. It is said that St. Peter's was the first church to be established within the Oakland town limits. St. Peter's parish served the needs of the western part of Allegany County until the formation of Garrett County in 1872. At that point, it continued to serve all of Garrett County until 1909 when St. Ann's parish was established in Grantsville.

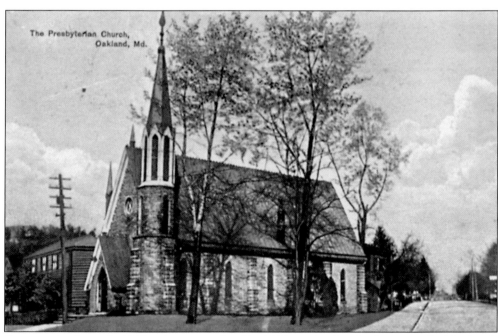

Construction began in 1868 and was completed in 1869 on what is today known as St. Matthew's Episcopal Church. Known for many years as the Garrett Memorial (Presbyterian) Church, this edifice was built by members of the Garrett family as a memorial to Henry Garrett. Several presidents, including Grant, Garfield, Harrison, and Cleveland, have worshiped here.

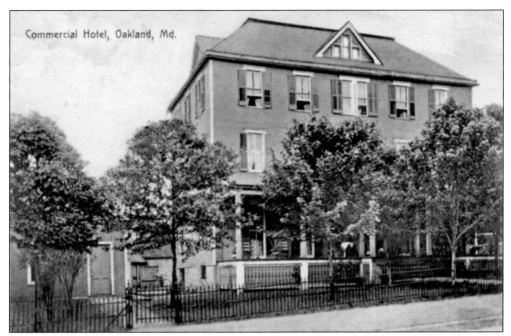

The sender of this card writes, on December 15, 1910, "My dearest daughter Maybelle. Sleighing and snowing. A regular blizzard of weather. Your father, D. H. Shanaman." Shanaman stayed at the Commercial Hotel, which was opened by S. M. Miller on Second Street in Oakland during the latter part of the 19th century.

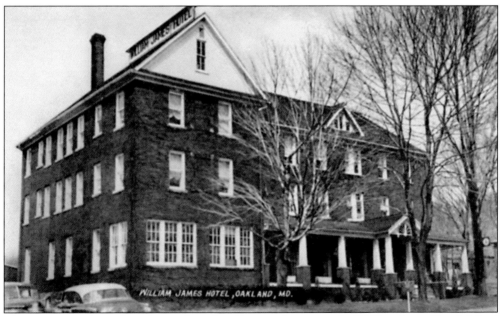

The Commercial Hotel was later enlarged and become known as the William James Hotel: "Cool nights—warm days, Phone Deerfield 4-3317, The William James." The hotel's name came from its owners, William Davis and James Towler. It had several proprietors prior to being razed in 1963. First United Bank and Trust currently occupies the site.

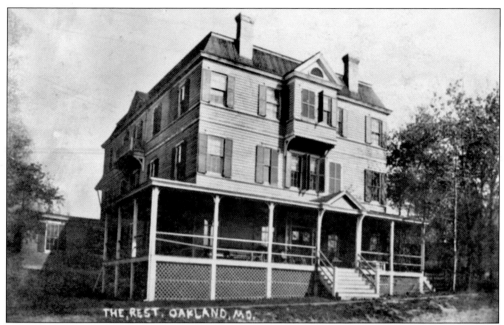

The Rest was a large, three-story house that served as a summer hotel and was located on Seventh Street at the corner of Alder Street. The Rest would undergo several changes in ownership and patronage prior to its being sold in 1934 and remodeled into apartments. The back of this 1910 postcard reads, "Dear Miss Walsh: Thanks for the letter. Hope you will find it agreeable to pay a word to Miss McGill in Ernest's behalf, especially as to his losing the work. Sincerely, Mrs. E. W. Emery."

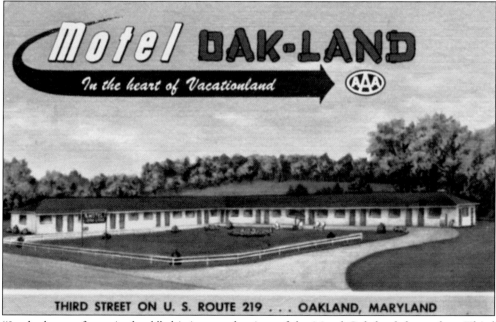

"In the heart of vacationland," this is an early view of the Motel Oak-land, located on Third Street (U.S. Route 219). It boasted "Eighteen units, tile baths, Simmons beauty rest springs and mattresses. Phone Oakland 2-2602."

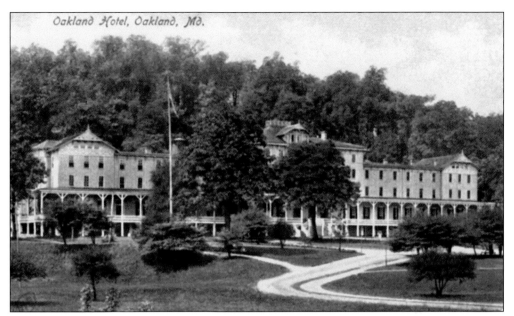

The B&O Railroad erected the Oakland Hotel in 1875 to share in the success of the area as a summer resort. The 131-foot-long wood hotel was four stories high. It featured a ballroom, a large dining room, and even a children's dining room. The sender of the above 1908 postcard writes, "Miss Bertha, there was a banquet here Friday night. You may imagine it was business for me. Donald."

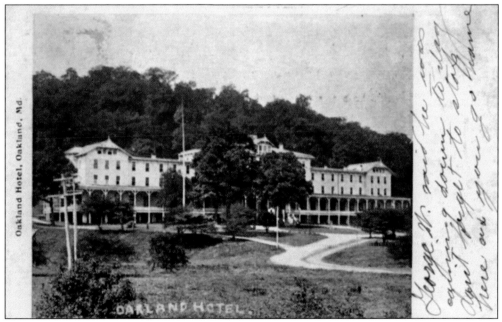

One of the Oakland Hotel's guests included Alexander Graham Bell, who in 1883 installed the first telephone line in Garrett County. This spanned five miles and connected the B&O's Oakland and Deer Park Hotels. The hotel initially had 110 bedrooms, with 82 added later. This postcard, dated April 6, 1908, reads, "Dear Hazel: Aunt Susie and I are here today. Hope you are as well as when I saw you. Uncle Bill." The hotel closed about that same year and was razed in 1911.

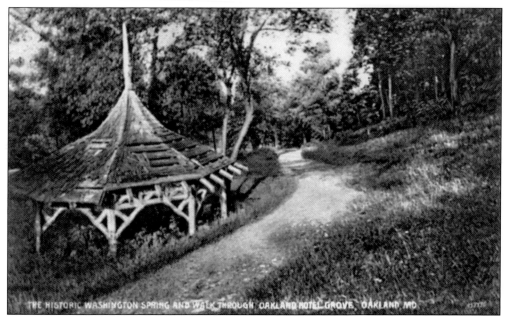

The Historic Washington Spring, with its peristyle roof, lay adjacent to the path through the Oakland Hotel Grove. There guests and visitors at the Oakland Hotel used the waters and spring location to have picnics or just sit on the benches. The spring received its name because Gen. George Washington once stopped here to quench his thirst on September 26, 1784, while on a trip over the mountain.

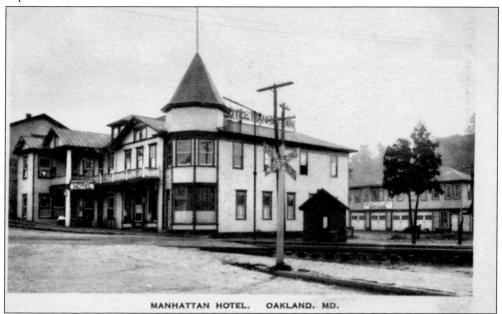

MANHATTAN HOTEL. OAKLAND, MD.

The Manhattan Hotel building was originally constructed in 1896 on the corner of Second and Oak Streets by Mrs. Harriet McCloskey. There were several owners of the Manhattan during its operation. In the early morning hours of May 14, 1956, a fire struck, causing over $20,000 in damage. The building was razed soon afterwards. Notice the automobile garage in the rear used by guests of the Manhattan Hotel.

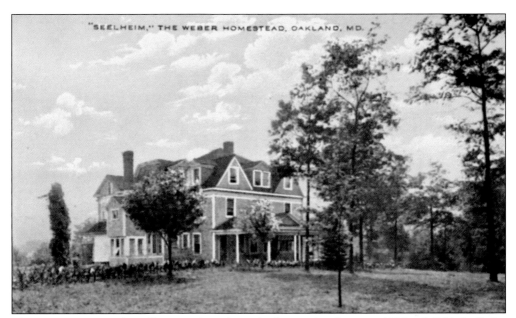

The Queen Anne–style Seelheim is a large home built sometime between 1898 and 1904. Seelheim is significant not only because of its architectural quality, but because it was the homestead of Henry Weber, a nationally prominent horticulturalist and local florist and landscape artist. The back of this early-20th-century postcard reads, "We are being entertained by the Webers. They are a large family having a very large series of greenhouses."

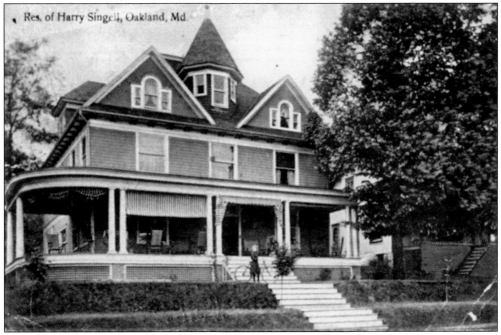

This postcard is dated 1910 and depicts the Queen Anne–style residence of Harry Sincell on North Second Street. The sender writes to her friend in Washington, "Oh, how many times have we passed this beautiful house on our numerous walks to Oakland. I have a whole book to tell you when I see you. With love, Lana."

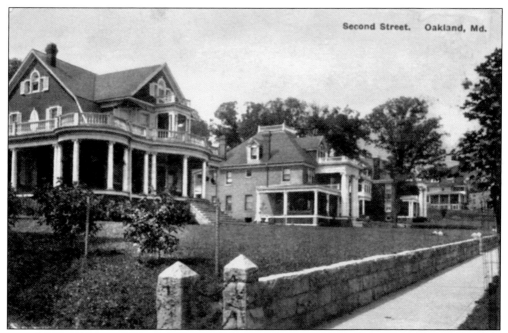

Dated November 16, 1920, the postcard above depicts several magnificent Second Street homes representative of the Colonial Revival and Neoclassical styles of architecture. The back reads, "Hello Cara. We got here OK. Was two hours and forty minutes coming. Never changed gears. All was well. Didn't get a bit cold. Stephen".

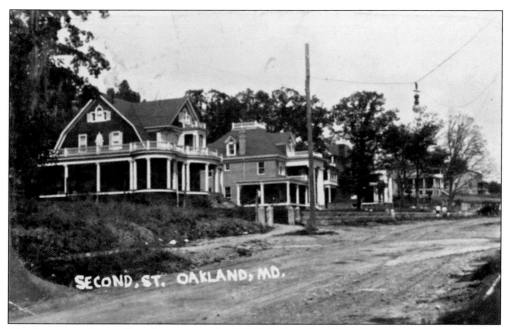

This is a somewhat earlier view postmarked 1914, before the sidewalk was built. It reads, "You little snipe. Why under the sun don't you write and tell me all the latest gossip? I suppose you are too heavily engaged with your spring cleaning. I'm having the time of my life. Gene. Oh yes! Is Uncle Marsh going to teach?"

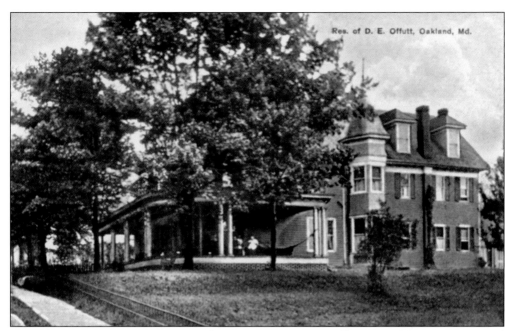

Res. of D. E. Offutt, Oakland, Md.

This was the residence of Daniel E. Offutt on Second Street. Offutt owned the "largest general merchandise store in Western Maryland" and also served as president in the 1888 Garrett County Bank incorporation. On July 26, 1912, the sender of this postcard wrote, "I just arrived with the cyclone. It was something awful. Hope I may never experience another like it. The place doesn't look like this picture now. Everything is blown or broken." Some sources state that the Offutt house depicted here was constructed about 1870.

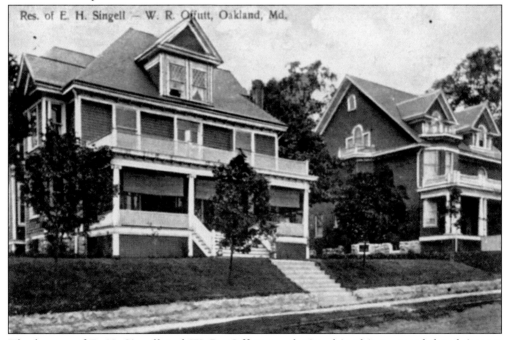

Res. of E. H. Singell — W. R. Offutt, Oakland, Md.

The homes of E. H. Sincell and W. R. Offutt are depicted in this postcard dated August 22, 1912.

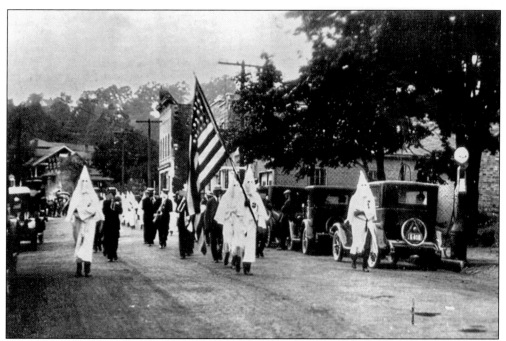

The Ku Klux Klan was on parade and marching in downtown Oakland on July 23, 1925. This was in an era when the KKK was on the rise throughout much of the country. (Collection of Rev. John A. Grant.)

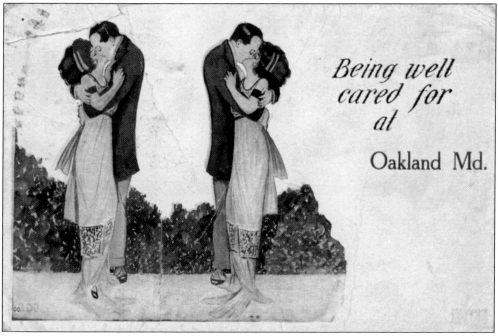

The year was 1915, and people were being very well cared for in Oakland, Maryland. The young man who sent this card to a friend in Frostburg writes, "Miss Laura, the Frostburg State Normal team played basketball here Saturday night and beat Oakland. Do you know any of their team? Lloyd Casteel."

Two

Mountain Lake Park, Loch Lynn, Deer Park
Heaven and Sin

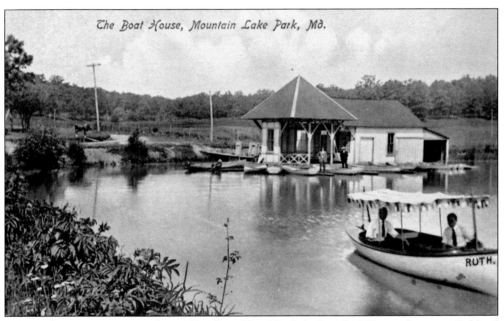

The Boat House, Mountain Lake Park, Md.

In 1881, four prominent men from Wheeling, West Virginia, bought 800 acres between Oakland and the resort of Deer Park, which had already been well established by the B&O Railroad. Their purpose was to establish a Chautauqua-type resort founded upon Christian principles, where ministers, educators, and lay leaders of the church could be trained and study in an environment of high moral tone. They called it Mountain Lake Park. It was founded and organized in 1881 and laid out in 1882 under the auspices of the Mountain Lake Park Association, an organization composed of clergy and laymen primarily of the Methodist Episcopal Church. Mountain Lake Park was noted for its 35-acre lake and more than 200 cottages and houses. Postmarked 1909, the sender writes, "Eleanor, this is the peace you would enjoy. Haven't been to the lake yet, but expect to in a short time. Sincerely, Your Pastor, Morgan." Someone printed the name Ruth on the boat depicted on the postcard.

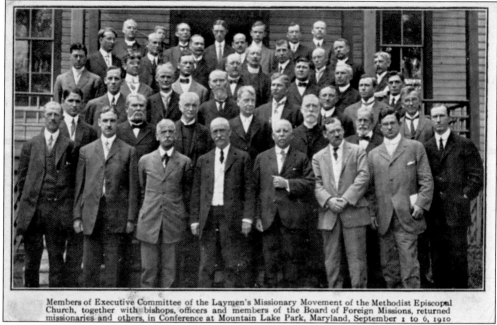

Members of Executive Committee of the Laymen's Missionary Movement of the Methodist Episcopal Church, together with bishops, officers and members of the Board of Foreign Missions, returned missionaries and others, in Conference at Mountain Lake Park, Maryland, September 1 to 6, 1910

Taken at a conference held in Mountain Lake Park from September 1 to 6, 1910, this photograph is of the executive committee of the Laymen's Missionary Movement of the Methodist-Episcopal Church. Included in the group are returned missionaries, bishops, officers, and members of the Board of Foreign Missions. The back promotes an upcoming convention with the message, "Do not miss this opportunity. Your Pastor counts on you."

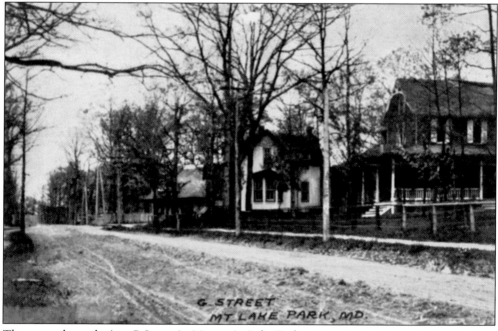

The scene above depicts G Street in Mountain Lake Park.

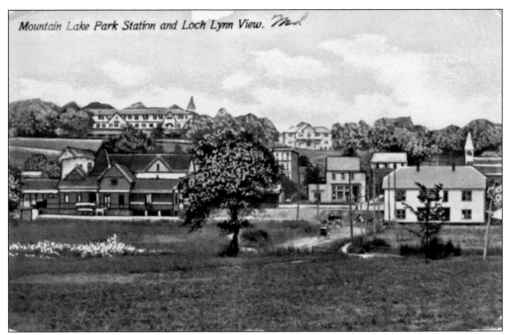

Mountain Lake Park Station and Loch Lynn View. *Mol*

Although the town would not be officially incorporated until 1931, Mountain Lake Park had by the turn of the century become a well-known and popular resort. The B&O Railroad depot for Mountain Lake Park is featured on the lower left. Above it and across the tracks is the Loch Lynn Heights Hotel, while at the center top is the hotel's recreation building.

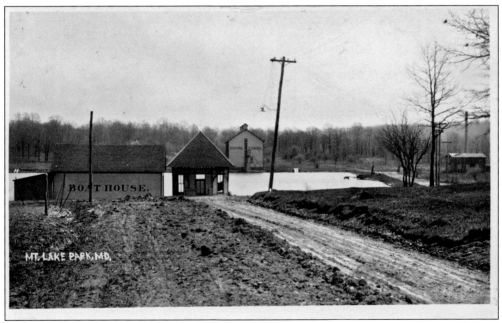

BOAT HOUSE.

MT. LAKE PARK, MD.

In 1894, a new boathouse had been built on the lake. The lake had been enlarged to 35 acres that same year at a cost of $11,300.29. On August 11, 1908, the sender of this postcard writes, "Dear Eve, haven't tried the lake yet, but expect to in a short time. Am still tickled to the point of tears. Love, Edith."

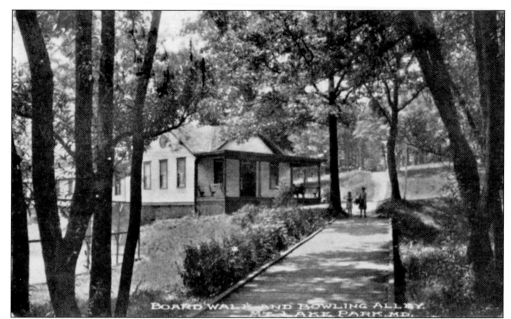

In 1906, a combination bowling alley and billiard parlor was constructed. It was built alongside a boardwalk constructed from the bowling alley to the post office down by the railroad that served the community. A sampling of meetings held at Mountain Lake during the 1910 season ranged from the Christian Workers, National Vigilance League, and Woman's Foreign Missionary Conferences to the Inter-State Good Roads Conference.

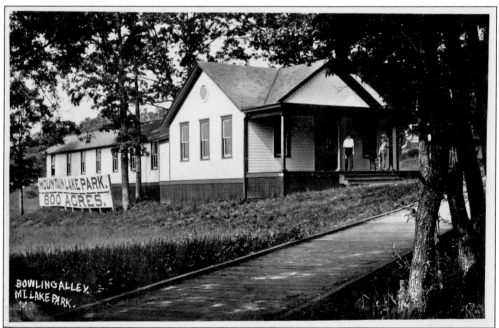

This photograph of the bowling alley and billiard parlor also depicts a sign promoting the 800-acre Mountain Lake Park community. About 1944, this building was turned over to the Town of Mountain Lake Park and currently serves as the town hall on Allegheny Drive. The bowling alley portion, in the rear, was relocated elsewhere in the town for use as a private residence.

Along the boardwalk was Pilgrim's Rest. Within this rustic setting, travelers along the boardwalk could sit, read their mail, or simply talk theology. This particular scene is postmarked 1909. The back reads, "Did not forget you, but oh my this is so lovely you can hardly find the time to write. Hilty."

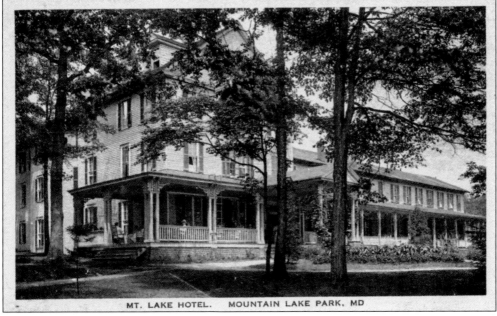

The Mountain Lake Park Hotel, the central portion of which was constructed in 1882, would by the turn of the century double in size. Postmarked July 17, 1906, the back of this postcard reads, "Having a wonderful time but very cold up here. Sleep under three blankets every night. The mountains are beautiful. All we are doing is resting. I want to be fat when I return. Reverend Fisher."

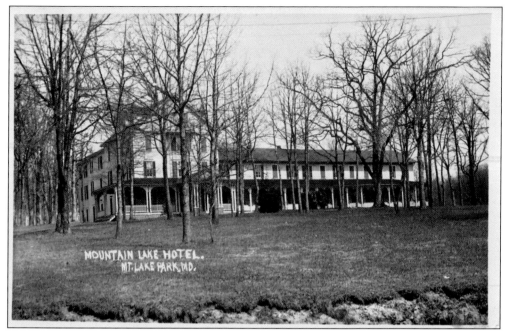

Mountain Lake Hotel.
Mt. Lake Park, Md.

For many years, excellent accommodations, service, and cuisine characterized the Mountain Lake Park Hotel, which was also the site of many important social functions. Tennis and croquet, steam heat, modern conveniences, a connected livery, free bus service, a garage in the rear, and the nearby train station, auditorium, and bowling alley were featured. The hotel remained open until the early 1960s. This photograph is postmarked August 8, 1908.

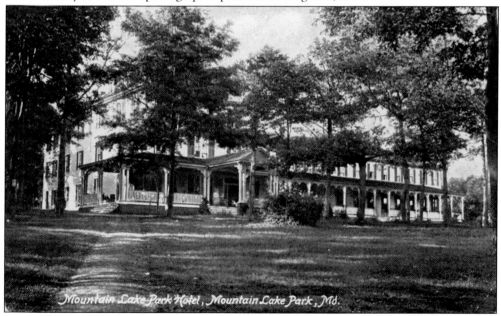

Mountain Lake Park Hotel, Mountain Lake Park, Md.

Postmarked 1910, the sender of this card writes, "We are all spending the day at Mt. Lake Park with Bertha and Grover. Mountain Lake Park is a fine place to spend an outing." The Mountain Lake Park Hotel's furnishings were sold at public auctions in 1966. The Mountain Lake Park Hotel was razed in 1968.

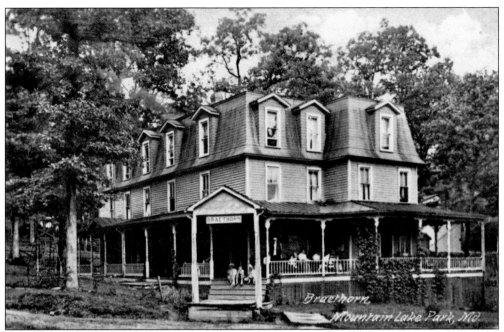

The Braethorn first opened to guests in 1897 and at one time could accommodate 50 people. Considered to have been one of the last large summer hotels in Mountain Lake Park, the Braethorn ceased to function in that capacity about 1940. The Braethorn featured a high mansard roof representative of the Second Empire architectural style. It stood at the corner of G Street and Route 135. The Braethorn was razed in 1988. This view is postmarked 1909.

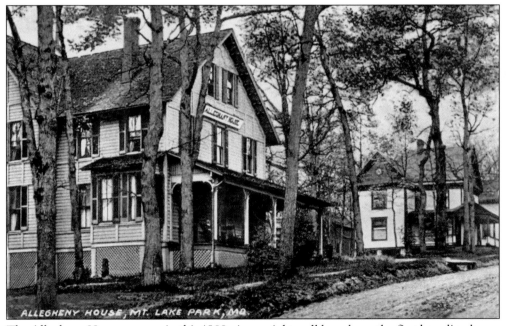

The Allegheny House, as seen in this 1909 view, might well have been the first boarding house in Mountain Lake Park, having opened for business in 1882.

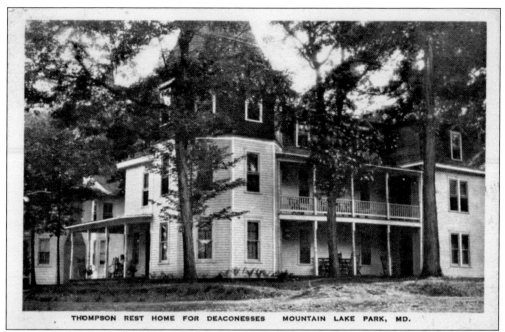

The Rest Home for Deaconesses, as depicted above and below, actually consisted of two large houses located on the northeast corner of Spruce and H Streets. The second house from the corner was constructed 1882 by the Reverend John Thompson.

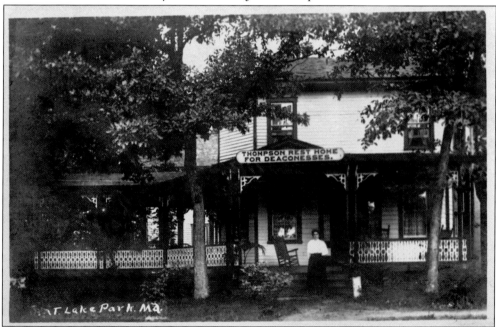

Upon Reverend Thompson's death in 1898, the house and property were purchased for $2,500 and turned into a rest home for deaconesses of the Methodist Church. The corner building was built about 1900 and was for some time known as the Burlington Hotel. This was purchased and, about 1917, connected to the original Thompson Rest Home for Deaconesses by a porch and dining room.

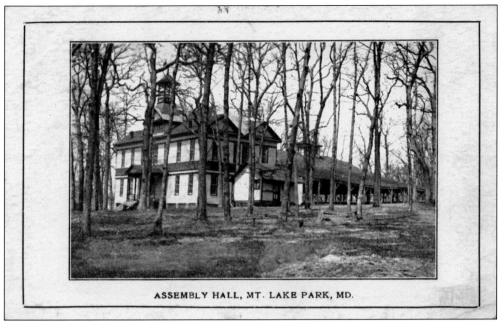

ASSEMBLY HALL, MT. LAKE PARK, MD.

The first public building in Mountain Lake Park was the assembly hall, which was dedicated in 1882. It was used for classes and meetings by organizations that met at Mountain Lake Park during the summer. The original auditorium, as seen above in this 1912 photograph, was attached to the assembly hall; it burned in 1941. Another auditorium collapsed from the weight of snow in the late 1960s. The Mountain Lake Park Assembly Hall has been restored to its original appearance.

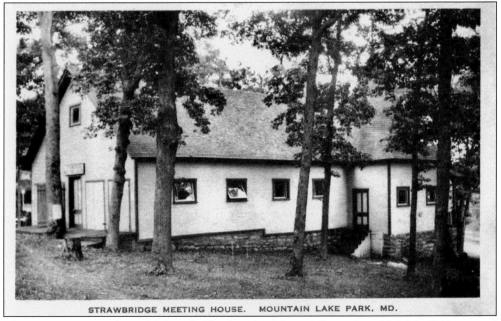

STRAWBRIDGE MEETING HOUSE. MOUNTAIN LAKE PARK, MD.

Above is Mountain Lake Park's Strawbridge Meeting House. The sender of this July 1908 postcard writes, "My Dear Leon, Come over and take me boat riding, won't you? Wouldn't we have a nice time seeing things if I had you here with me a while? Lovingly, Alice."

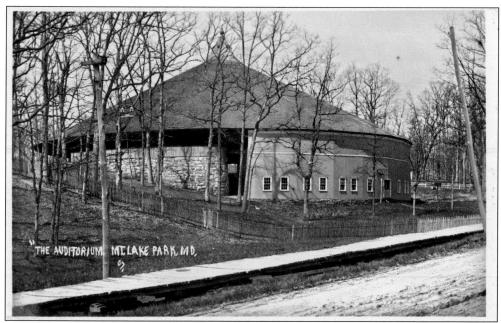

The Bashford Amphitheater, or auditorium, as depicted in this 1907 photograph, was constructed in 1899 and dedicated in the spring of 1900. It was over 170 feet in diameter, had a seating capacity of almost 5,000, and a stage which could accommodate several hundred people. It was built to accommodate the ever-increasing Chautauqua crowds and hosted such notable figures as William Howard Taft, William Jennings Bryan, Mark Twain, and Billy Sunday.

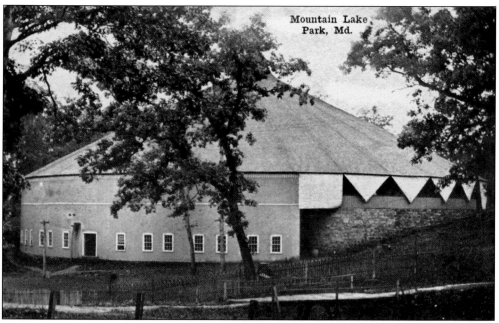

The amphitheater was architecturally noteworthy because there were no interior posts or supports to obstruct the view of the audience. This was accomplished by way of exterior supports around the structural perimeter, which were connected to a complex webbing of roof beams and rafters.

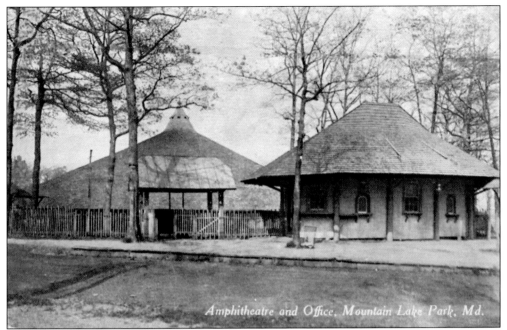

Amphitheatre and Office, Mountain Lake Park, Md.

In 1939, the amphitheater's use was discontinued. By 1944, the structure was in a dilapidated condition and posed a fire hazard. With no one to assume responsibility for its maintenance, the amphitheater was razed in 1946. Depicted on the right is the eight-sided ticket office that served the amphitheater. It stood at the rear of the amphitheater and was built into the hill.

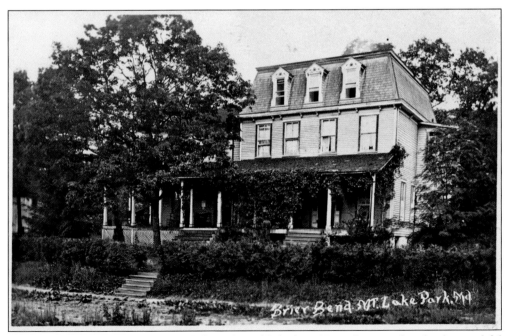

Brier Bend Mt. Lake Park, Md.

This is Brier Bend, a seminary schools for girls established in 1887 and operated under the watchful eye of Miss Swan. Girls who attended the nearby summer camp meetings would sometimes stay on, complete their studies at Miss Swan's, and perhaps go into missionary work.

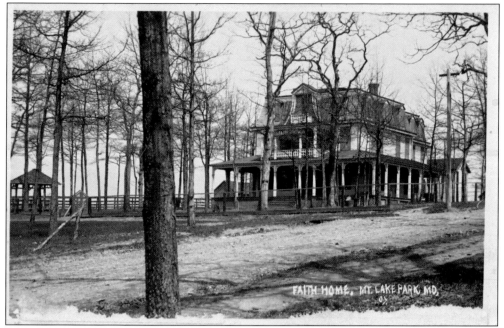

The Faith Home of Mountain Lake Park, as seen above in this 1907-postmarked depiction, was located on Deer Park Avenue and was one of the area's earlier hotels.

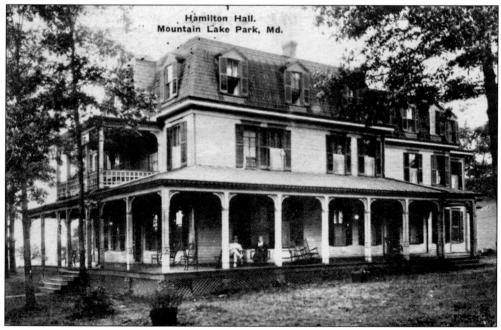

As shown in 1926, the Faith Home later became known as Hamilton Hall and went on to serve Mountain Lake Park for many years. The sender writes to Miss Pauline White of Atlantic City, "Having a wonderful time. Your pal, Mary."

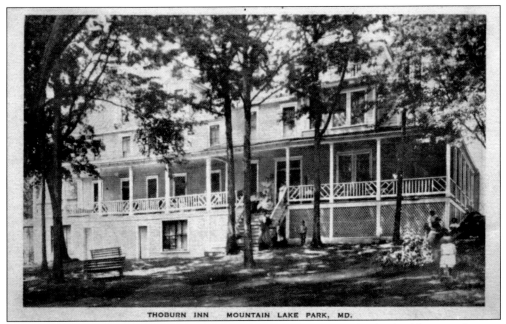

Once owned by the well-known Railroad evangelist, Jennie Smith, this building was known as the Thoburn Inn and was located next door to the Braethorn. A guest staying here in 1912 writes, "This is a wonderful place and we are having a wonderful time." Jennie Smith was also a leader and organizer in the temperance movement and once organized a temperance convention at Mountain Lake Park.

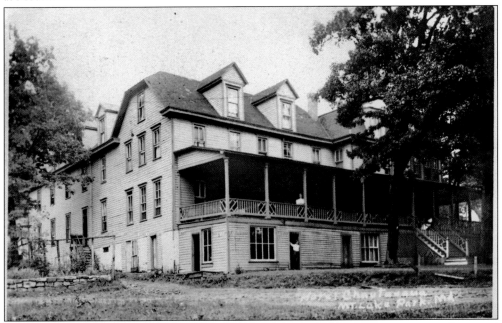

As seen here, the Thoburn Inn later became known as the Hotel Chautauqua. The Hotel Chautauqua was one of Mountain Lake Park's well-known hotels. The sender of this Hotel Chautauqua view, also postmarked 1912, writes, "Ann: Am spending the day here and took dinner at this hotel. Received the cushion ok. Thanks! Gladys."

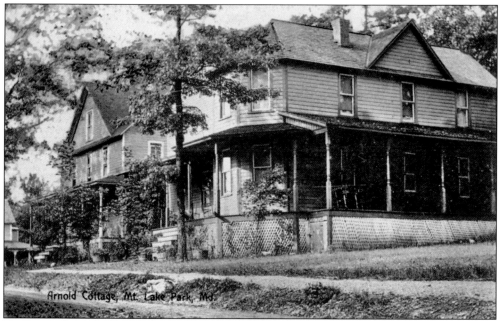

The date is August 2, 1911, and the postcard above depicts the Arnold Cottage at Mountain Lake Park. Like all of the park's boarding houses, the Arnold was a very respectable cottage where the meals were most likely served promptly at 8:00 a.m., 1:00 p.m., and 6:00 p.m.

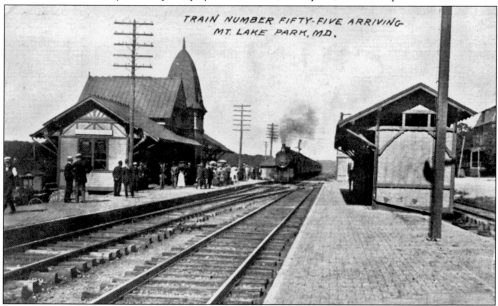

The wooden-frame B&O train station for Mountain Lake Park was designed by the Baltimore architectural firm of Baldwin and Pennington. Early photographs show that the station once had a square tower with a bell-cast roof similar to Oakland's brick B&O station. The sender writes, "Master Vance, this is the way the old 'choo-choo' looked that brought mother and me up here. There is a lady here who tells stories to little children every morning. I like that." This 1909 scene depicts B&O train number 55 traveling through along the main line to Grafton, West Virginia.

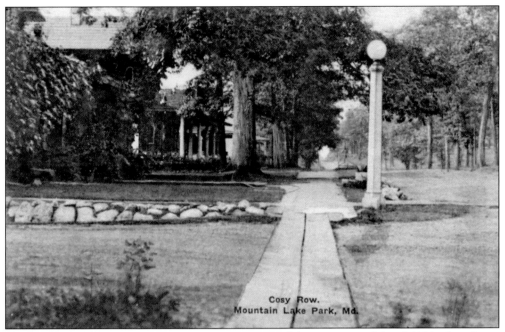

This is Cozy Row, Mountain Lake Park, as it appeared from a postcard dated 1929. Electric arc lights were installed in Mountain Lake Park in 1894.

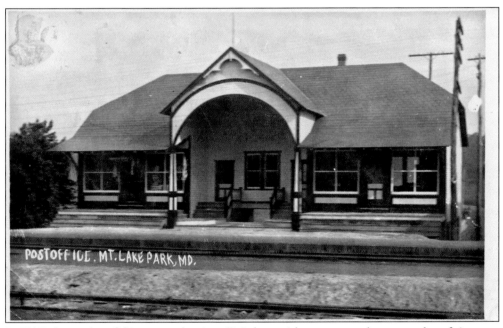

In 1907, the sender of this postcard writes, "My best wishes to you and yours, and a safe journey home." This is the old post office at Mountain Lake Park that stood along the tracks near the train station. Although trains provided mail service to Mountain Lake Park, house-to-house service would not be instituted until 1962. Prior to that time, a trip to the post office was a daily routine.

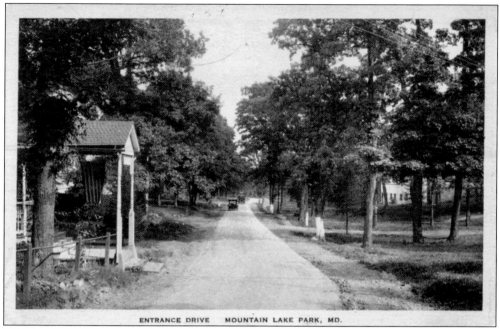

ENTRANCE DRIVE MOUNTAIN LAKE PARK, MD.

The scene above depicts the entrance drive to Mountain Lake Park as seen from a postcard dated August 5, 1932. "Dear Trace, just a card to say I have been thinking of about you so much while at camp. Hope this will find you much happier. Love, Ruth."

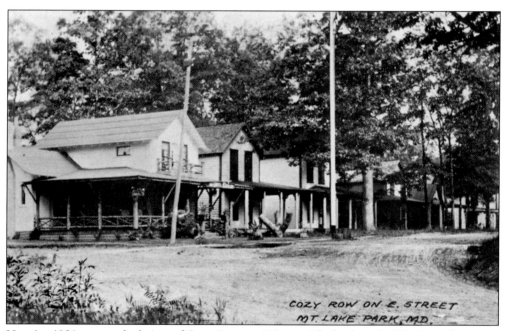

COZY ROW ON E. STREET
MT. LAKE PARK, MD.

Here is a 1921-postmarked view of Cozy Row on E Street. The back reads, "Having a fine time, Lilly." The owner of the home on the corner referred to it as Journey's End.

52

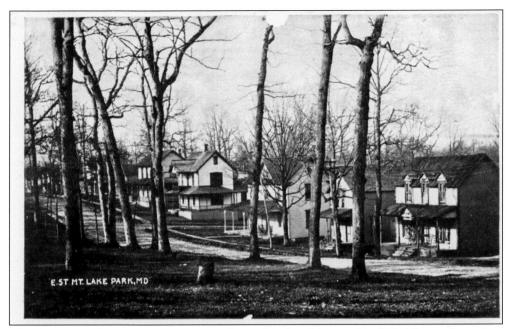

This depiction of E Street in Mountain Lake Park is dated August 31, 1912. The sender writes, "Dear Mother: Arrived last night about 10:30 and there were fellows here to meet me. The eats are fine but the hotel is pretty poor. You probably thought it funny I wrote to Helen but I have been going with her some lately. Ask papa if he cares if I get a leather overcoat."

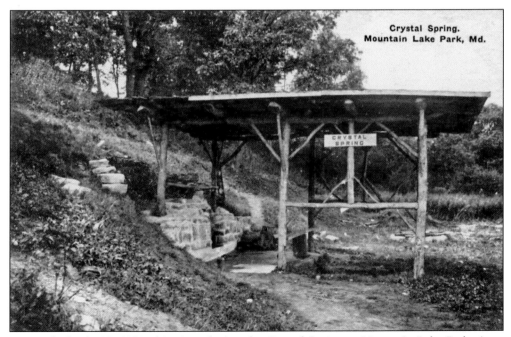

Postmarked July 29, 1924, this view depicts the Crystal Spring at Mountain Lake Park. Aunt Alma writes, "This Spring is at the head of the lake. I have walked down there two or three times." Crystal Spring was widely known for its pure water.

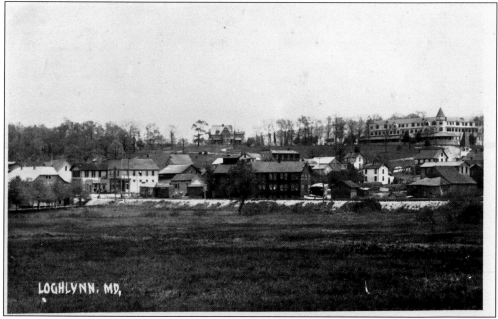

LOCHLYNN, MD,

"If you want to sin, go to Loch Lynn, But for Jesus sake, go to Mountain Lake." Loch Lynn was originally founded as Lake View on April 1, 1882. Upon its development in 1894 and subsequent name change, Loch Lynn Heights, as seen here in 1908, would provide many of the pleasures, such as dancing, that were forbidden "across the tracks" in the adjacent Chautauqua religious community of Mountain Lake Park.

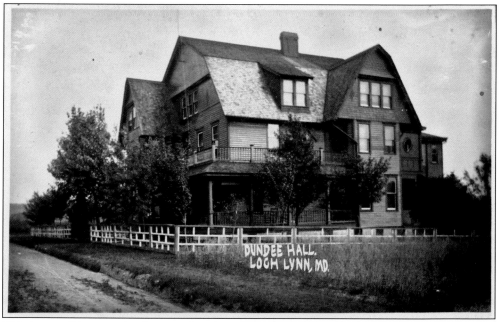

DUNDEE HALL.
LOCH LYNN, MD.

This is one of the very fine homes of Loch Lynn in the early 20th century, Dundee Hall. It was located on the hill just east of the Loch Lynn Heights Hotel and is visible to the left of the hotel as seen in the postcard atop this page. The hotel advertised a table of vegetables, berries, chicken, lamb, fresh fish, good beef, and "everything in season the market affords."

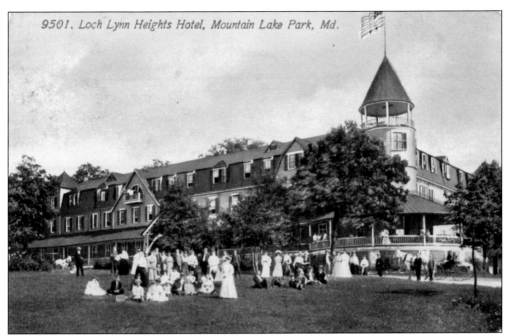

The town of Loch Lynn Heights was officially incorporated by an act of the Maryland legislature on April 4, 1896. The Loch Lynn Heights Hotel, as seen in this 1913-postmarked view, was constructed in 1893–1894 and opened in the summer of 1895. The sender writes, "Dear Pearl—Have just spent four days here. It was real fine. Hope you are about ready for school."

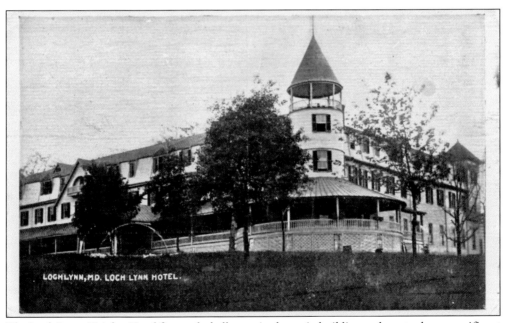

The Loch Lynn Heights Hotel featured a ballroom in the main building and was truly a magnificent resort facility with a 280–foot-long veranda. The sender of this 1909 postcard writes, "Did not forget you, but oh my, this is so lively a place, you can hardly find time to write." The Loch Lynn Hotel was destroyed by fire in September 1918.

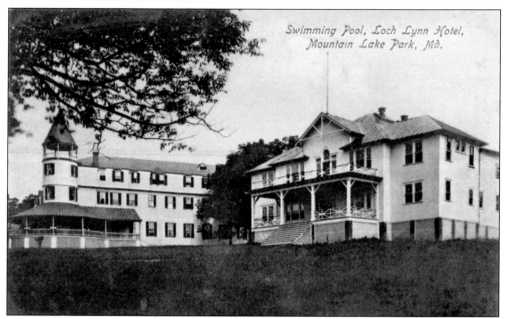

Swimming Pool, Loch Lynn Hotel, Mountain Lake Park, Md.

The large frame building that stood near the Loch Lynn Heights Hotel was known as the Casino (right). This recreational facility featured a casino, bowling alley, billiards, card rooms, and a 15-by-40-foot heated swimming pool. The Casino, or "swimming pool building" as it was also known, was the last surviving remnant of the area's great summer resort hotels. It was demolished during the summer of 1987.

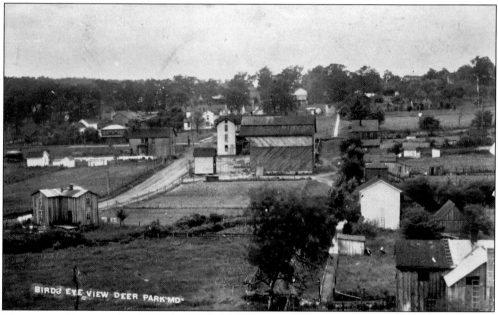

BIRDS EYE VIEW DEER PARK MD.

The town of Deer Park is located about six miles east of Oakland. There are two explanations as to how the town received its name. The first is that the area was given the name prior to the French and Indian War because the region was a reputed resort for wild deer. A second explanation is that in 1870, Henry Gassaway Davis and John Work Garrett enclosed 10 acres of land at this site for a deer refuge.

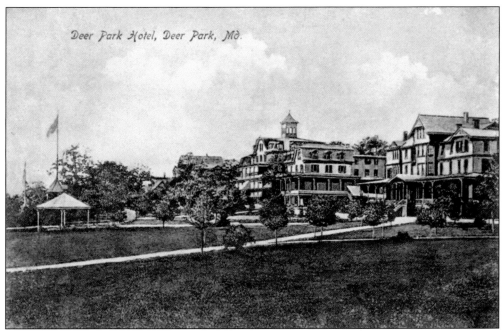

Although a post office was established at Deer Park as early as 1864, its real growth began with its development as a summer resort by the B&O Railroad. The Swiss alpine–style Deer Park Hotel, which was built in 1872 under the watchful eye of John Work Garrett, was officially opened on July 4, 1873, and initiated Garrett's efforts to develop the area as a resort community.

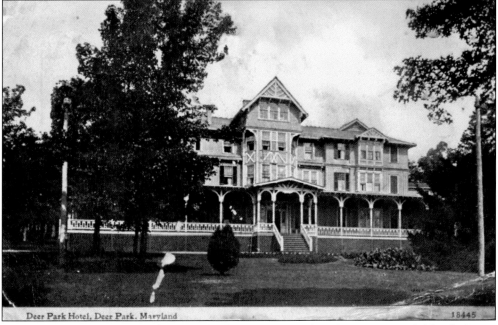

The original Deer Park Hotel consisted of 104 rooms, parlor, dining room, children's dining room, reading room, laundry, bakery, kitchen, and servants' quarters. As depicted in this 1916-postmarked view, the Deer Park Hotel was situated on the route of the B&O line on the summit of the Allegheny Mountains, 2,800 feet above sea level.

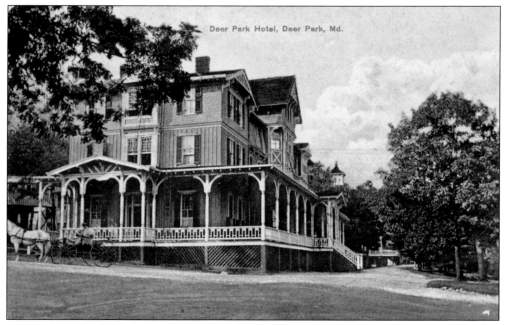

A billiard room and four bowling alleys were located in a separate building. Later two swimming pools, a music pavilion, a golf course, and clay tennis courts were provided. As seen in this 1909 photograph, carriage rides over a 500-acre tract of land known as Peace and Plenty at the time of Garrett's purchase were also provided to hotel guests.

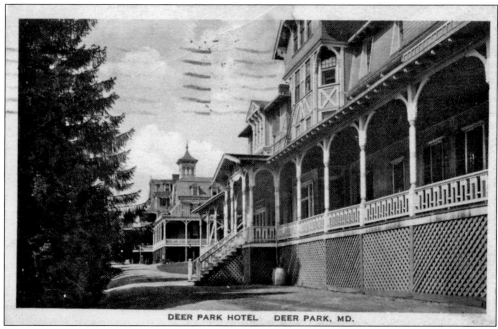

The Deer Park Hotel became so successful that in 1881 two annexes were added that doubled the hotel's accommodations. This view of the Deer Park Hotel complex, as seen from one of the annexes, is from 1927. By the 1920s, the B&O had already discontinued direct management and ownership of the Deer Park Hotel.

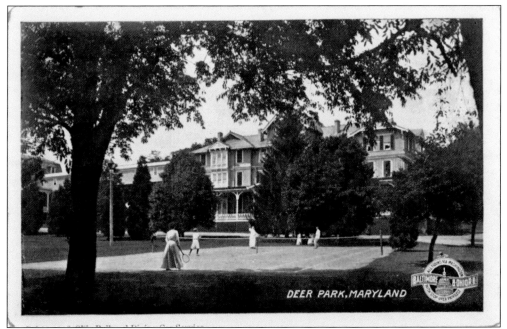

In 1929, then-owner Henry S. Duncan lost title to the resort in the stock market crash. The resort never reopened. Prior to its demolition for lumber and war material in 1942, the Deer Park Hotel had played host to Presidents Grant, Benjamin Harrison, Cleveland, Garfield, and McKinley. Note the B&O Railroad logo in the corner, "All trains via Washington with stop over privilege." Tennis anyone?

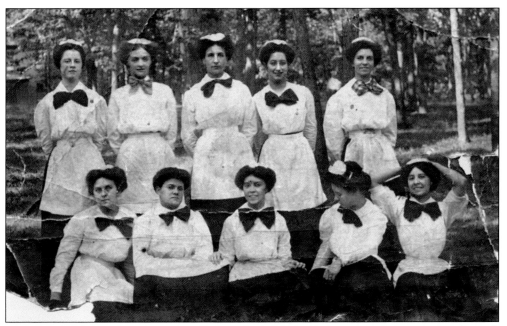

The year is 1912, and these are the waitresses at either the Deer Park or Mountain Lake Park Hotel. The postcard states that all but two of these girls are college students. Can you guess which ones?

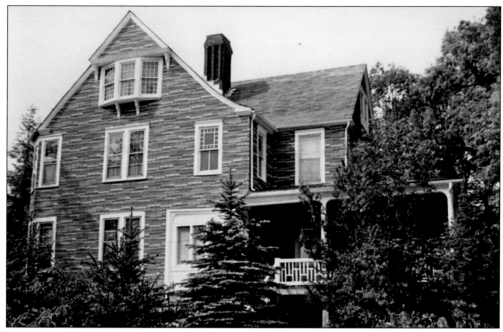

On June 2, 1886, Pres. Grover Cleveland (1837–1908) was married in a beautiful White House ceremony. The next day he and his bride, Frances, boarded a private B&O railcar and arrived at this Deer Park Hotel cottage, henceforth known as Cleveland Cottage and shown here in the mid-1970s. The press soon followed. With the cottage surrounded by railroad detectives, the reporters climbed trees and bribed servants to get a story. The honeymoon lasted about a week. (Joseph E. Revell Photograph.)

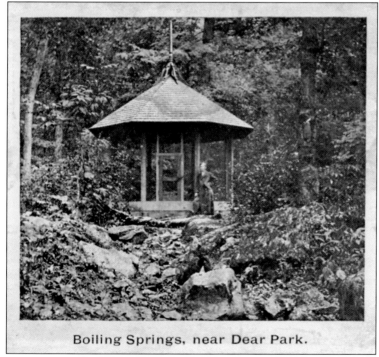

Boiling Springs, near Dear Park.

Boiling Spring, depicted here in 1909, was developed by the B&O Railroad in 1873. It was known as one of the finest natural springs in the country and the original source for Deer Park Water. Boiling Spring water was served in the dining cars of the B&O Railroad as well as the Deer Park Hotel. The sender writes, "This is just one more of the beautiful places we have seen on our drive. The girls are having a delightful time."

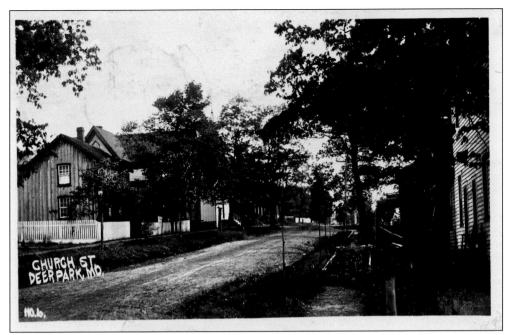

Above is Church Street as it appeared in 1910. The sender writes, "Miss Gertrude, will you please send me my piece of drawn work? It is in the top left-hand drawer of the bureau in the hall. We are invited to a fancy work next week. Go in the morning, have luncheon, and home at 4:00 p.m. Eva gave me the thread to finish that piece. Love to all, Lottie."

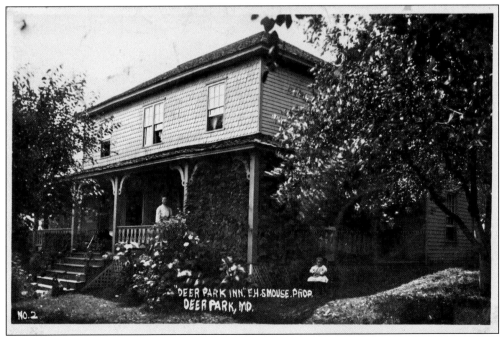

Below is the old Deer Park Inn, run by proprietor E. H. Smouse, as it appeared in 1910. Eva writes, "Miss Gertrude. We could not find a card with the Garrett Cottage on it. Received books ok. I mailed the silks Monday. They were sent here by mistake. Love to all."

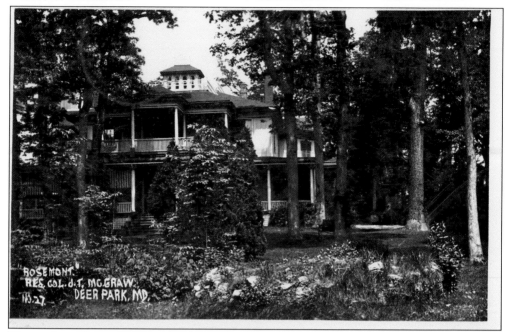

The sender of this postmarked view dated September 1, 1910, writes, "This used to be the house of Senator [Henry Gassaway] Davis. I like it. Love, Lottie." As shown, the site was later known as Rosemont, the residence of Col. J. T. McGraw.

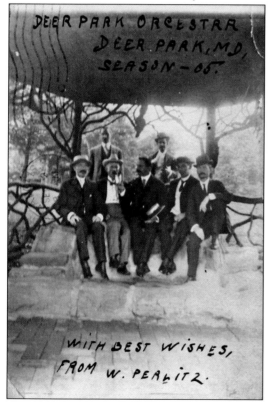

It is the 1905 summer season, and the Deer Park orchestra is assembled. Afternoon concerts in the town parks were a pleasant summer diversion in the late 19th and early 20th centuries. Joseph Feldstein, the late father of the author, traveled from Cumberland on a regular basis as a young man to play in the Deer Park orchestra, of which he was a member.

Three

OTHER TOWNS
Built by Coal, Timber, Rail, and Road

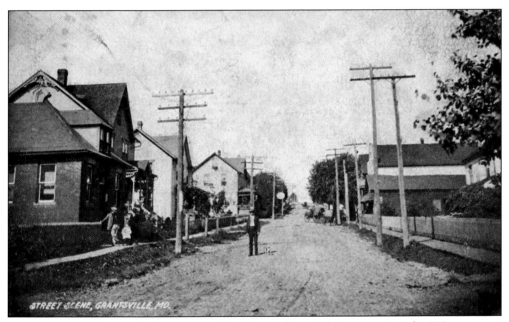

STREET SCENE, GRANTSVILLE, MD.

In 1785, Daniel Grant, a businessman and innkeeper from Baltimore, patented 1,100 acres west of the Casselman River and along the Braddock Road under the name Cornucopia. Upon his moving to the site about 1795, the settlement became known as Grant's Village or Grant Settlement. When the Cumberland, or National, Road was built through in 1815, the original site was abandoned, and the community, which consisted of about a dozen structures, was relocated about a half mile north along the new road. In 1822, a post office was established under the name of Tomlinson's at Little Meadows. The name was later changed to Little Crossings, and in 1846 was relocated to and named Grantsville. Grantsville owes its early growth to the development of the National Road. As many as 14 stagecoaches per day would pass through Grantsville going both directions during the National Road's height in the 1840s. Grantsville was incorporated in 1864. This view of the National Road, looking west through Grantsville, is postmarked 1908.

"I've some pretty warm work, but I like it in Grantsville, Maryland." In 1915, the sender of this postcard writes, "Master Henry: This is some nice place. Kate caught a fish. Harriet and Roy."

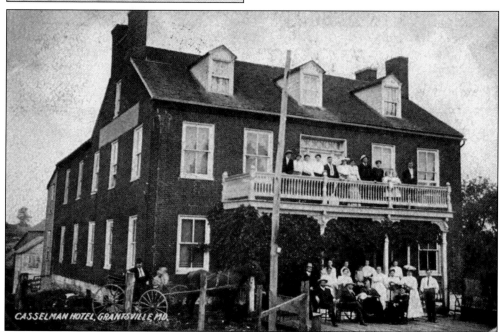

The Casselman Hotel, as depicted in this 1907 photograph, is located on Main Street in Grantsville. Solomon Sterner built the Casselman in 1842. This historic landmark, which has served travelers along the National Road for over 160 years, has also been known at various times through the years as the Sterner House, Drover's Inn, the Farmer's Hotel, and Dorsey Hotel. The Casselman remains probably the oldest hotel on Route 40 that has stayed in continuous operation to this day.

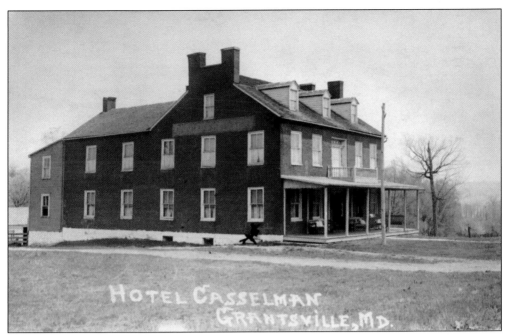

At the National Road's peak in the 1840s, over a dozen stagecoaches a day would pass by or perhaps stop at the Casselman. The sender writes, "Do you recognize this picture. Where the cross is, is our room. This is a fine picture of the old Sterner House. In the summertime, vines cover the porch nearly all over. Sister Alice." (L. J. Beachy Photograph.)

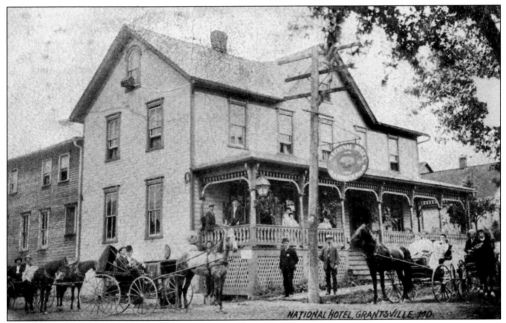

In 1837, Henry Fuller of Salisbury, Pennsylvania, moved to Grantsville. In 1843, he constructed the original portion of what came to be known as the National Hotel. The National Hotel was one of several inns and taverns built along the National Road during the 19th century. This photograph, postmarked May 26, 1909, identifies C. A. Bender as the proprietor.

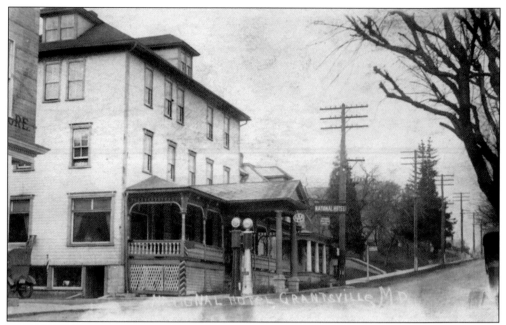

This is a much later view of the National Hotel taken from a card postmarked from 1941. The National Hotel was razed in about 1984.

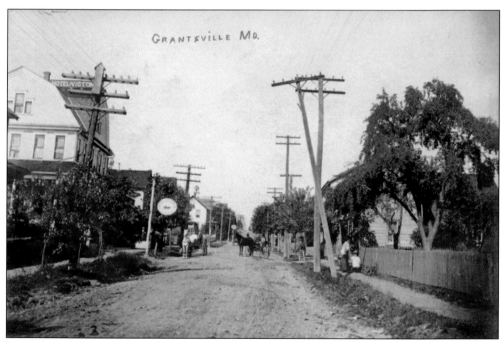

It was August 9, 1907, when this postcard of Main Street looking west along the National Road was sent from Grantsville. On the left stands the Victoria Hotel, while farther down the street one can see the sign from the National Hotel. The Victoria Hotel was constructed in a Colonial Revival style about 1837 and underwent several proprietorships. The sender writes, "Having a bully ride—roads rough as H here but beautiful scenery."

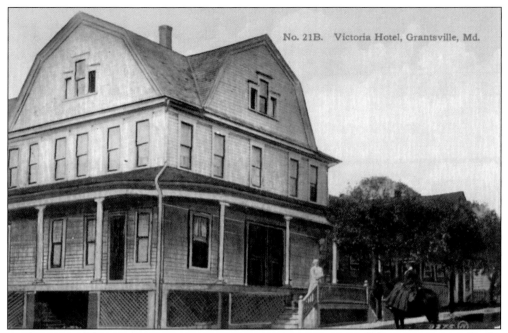

At the time of this 1908 view, M. E. Bevans was the proprietor of the Victoria Hotel. The hotel was considered a popular stopping place for tourists traveling the National Road. It was especially noted for its home comforts and was considered one of the newer types of hotels that were replacing the old tavern stands and inns. (E. K. Weller Photograph.)

Yoder's Country Market was a well-known destination point for country meats and bulk food. After more than 50 years of operation, the well-known Grantsville landmark closed its doors in October 2005. Locally produced foods such as dried corn and apples, maple products, noodles, apple butter, and canned meats were advertised on the back of this 1970s–era postcard.

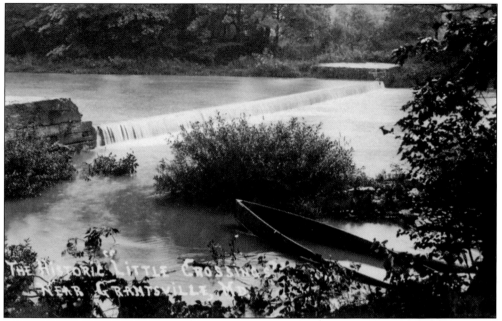

The above photograph was taken by Leo J. Beachy (1874–1927) and produced at his Mount Nebo Studio in Grantsville. Crippled from the age of 14, Beachy lived his entire life in the Grantsville area and maintained his residence at the family homestead, Mount Nebo. The photograph depicts the dam at the historic Little Crossings, also known as the Casselman River. The dam was used to provide water to run the water wheel at the nearby Stanton Mill.

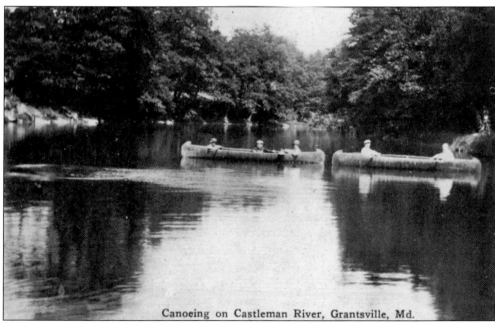

Canoeing on Castleman River, Grantsville, Md.

The pleasant early-20th-century postcard depicts "canoeing on the Castleman River" in Grantsville, Maryland. Depending on the source, Casselman was also quite frequently and earlier spelled Castleman.

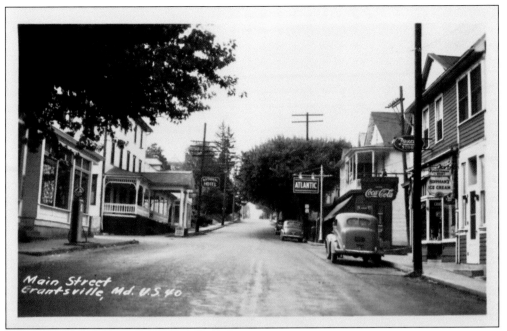

This is Main Street (U.S. Route 40) in Grantsville sometime in the mid–1940s, looking west. On the left is the old National Hotel, where dinner was being served, while on the right is the Keller Store, featuring Hoffman's Ice Cream, "A Good Reason to Stop."

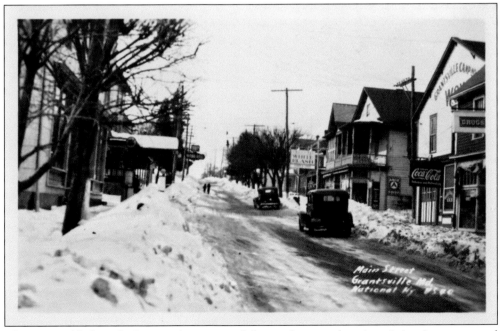

The postcard below depicts another scene of almost the same location. It is winter now and judging from the cars, we are in about the mid–1930s.

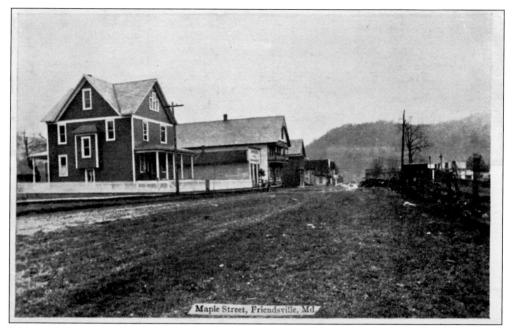

John Friend Sr. is considered to be the first permanent white settler in what is today known as Garrett County. The settlement, which he, his brothers, and their families established in 1765 on the Youghiogheny River, was on land purchased from the American Indians, as legend has it, for the price of one large iron cooking kettle. For some time the site was known as Friend's Fortune. It is today known as Friendsville. This is Maple Street, Friendsville, from a card postmarked August 27, 1910.

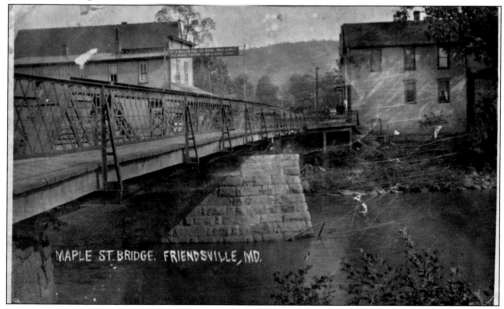

A post office had been established here as early as 1830 and was called Friends. In 1832, the post office department changed the name to Friendsville. This is Maple Street, looking east across the old Maple Street Bridge. What's that old sign say over the bridge? "Five dollar fine for driving or riding over this bridge faster than a walk."

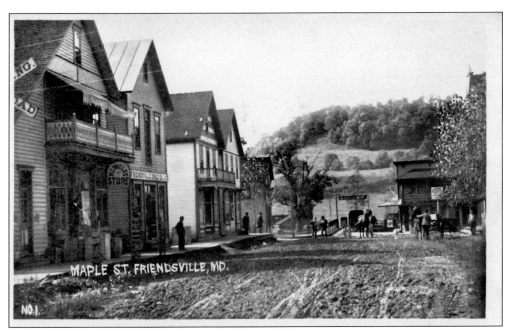

Looking west on Maple Street, on the left is H. L. Wolf's Store and the Friendsville Drug Company. On the right, in the background, just before crossing the old bridge, is the Central Hotel.

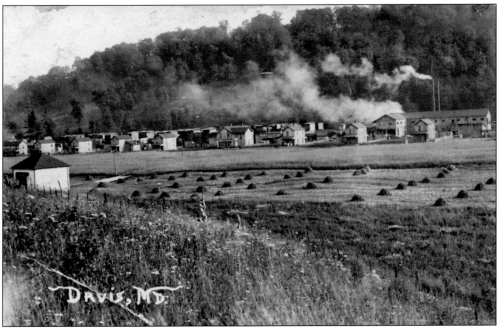

Located between Grantsville and Jennings was the timbering and lumber town of Davis. Established in 1913 by J. B. Davis, a lumberman from Pennsylvania, the site was located on a flat parcel of land north of Maryland Route 495. A sawmill with a capacity of 30,000 feet per day, a store, a post office, and 20 laborer homes comprised the community. Operations ceased about 1918, and little evidence remains today of the community's existence.

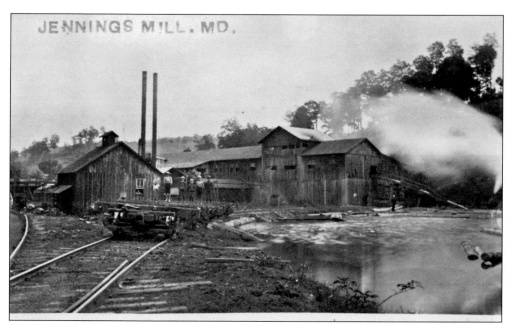

The Jennings brothers began their Garrett County lumber and timber activities in 1899 with the purchase of 6,368 acres. Although the ridges bordering their purchase along the Casselman River were abundant in timber, transportation posed a key problem. To remedy this, the brothers planned a standard-gauge railroad south from Elk Lick (later Salisbury), Pennsylvania. The mill, as depicted here, was constructed near the junction of Big Laurel Run and the Casselman River.

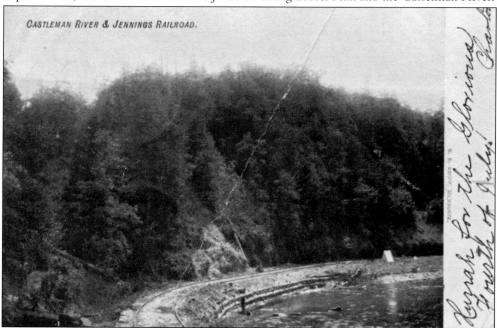

CASTLEMAN RIVER & JENNINGS RAILROAD.

With the rails laid in 1901, the Jennings Brothers' Railroad followed the south branch of the Casselman River southward almost to its source on the north slope of Meadow Mountain, for a distance of over 30 miles. Postmarked July 5, 1907, this postcard reads, "Hurrah for the Glorious Fourth of July! Charlotte."

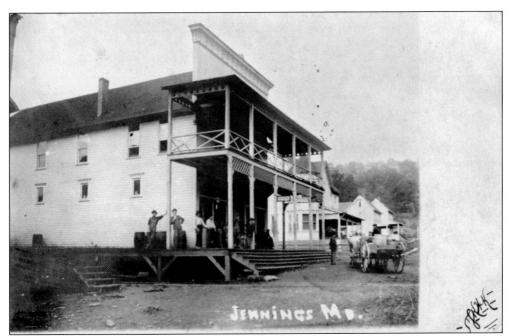

Logically enough, the center of all this timbering and railroading activity was named Jennings. The town had many homes, a hotel, a church, a school, and a company store, the Jennings Supply Company, which is portrayed in this 1907 photograph. In 1918, the mill closed. The railroad, however, remained and soon lent itself to the transport of coal.

This is the old Methodist Episcopal Church at Jennings as it appeared in a photograph postmarked September 26, 1910. The cornerstone of the present-day Jennings United Methodist Church on Hare Hollow Road, which basically remodeled and engulfed the original structure with a modern cut-stone material, reads as follows, "Cornerstone M. E. Church, July 1909, presented by J. B. Williams and Company, Marble and Granite Dealers, Frostburg."

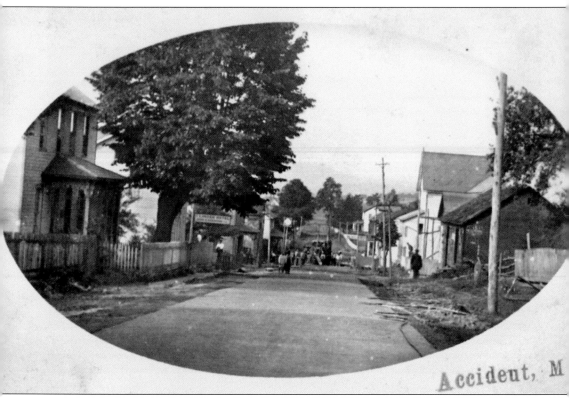

Accident, M

In 1774, Maryland's Lord Baltimore opened up the public lands "westward of Fort Cumberland" for survey and settlement. William Deakins Jr. and Brooke Beall, two land speculators from Prince George's County, quickly traveled to far Western Maryland. Deakins soon surveyed a large tract of 682 acres. The survey was no sooner completed than Brooke Beall and his surveyors showed up. Beall stated he had already surveyed this same tract, and had his axe marks on the trees to prove it. Deakins replied they had selected the same land by accident. Land was plentiful, the men were friends, and it was agreed Beall keep the surveyed site. This mutual claim led to the tract, and subsequently the town, being named Accident. This is Accident looking south from the center of town from a view postmarked July 31, 1914. The Linden Hotel is half way down the street on the left. John Robinson was the proprietor. The photograph depicts the paving of Accident's Main Street, also about 1914. The town was officially incorporated in 1916.

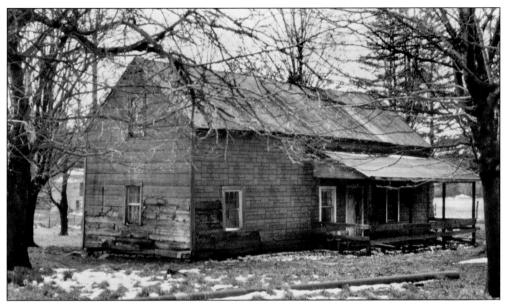

The Accident tract was later sold, resurveyed, and named Flowery Vale. James and Priscilla Drane were the area's first permanent settlers. Their home, depicted above in 1974, was a combination log and frame structure consisting of two sections. The larger section was erected about 1800, while the smaller portion was built about 1803. The historic Drane House was professionally restored between 1991 and 1994. It is Garrett County's oldest standing house. (Ronald L. Andrews Photograph.)

The postcard below is somewhat symbolic of Accident. In the early 19th century, the community was composed of many German immigrant and Pennsylvania Dutch Families. The sender of this card, postmarked July 31, 1914, writes, "Well Mother, we are coming to see you Sunday. You can look for us at breakfast, ha, ha. Hoping to see you. All your children, Mattie, Floyd, and Clayborne."

Numerous grist- and sawmills once characterized New Germany. The back of this 1915 postcard reads, "Dear Ernest, How are you all down there? I am getting real anxious to hear from you again. Buster helped Pa with the cattle and they didn't have no time to see you. Mary had a baby girl and that Dewitt girl had twins, boy and girl. Tell Clara I can crochet that lace. Love, Mother."

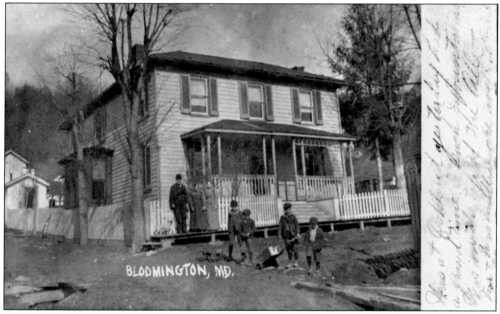

Bloomington, as depicted in this early-20th-century view, was located at the confluence of the Potomac and Savage Rivers at the base of Backbone Mountain in Garrett County. The town was originally laid out on June 17, 1849, and in the words of the surveyor, consisted of 39 lots near the mouth of the Savage River at the Potomac in what was than Allegany County. He called the town Bloomington.

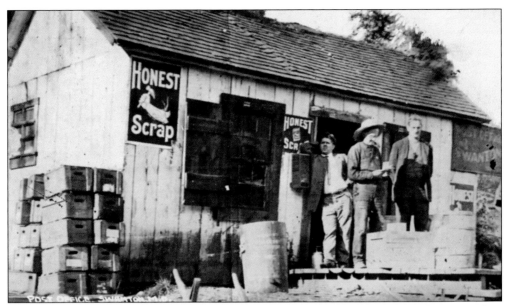

A post office at Swanton was first established in 1862. The community's growth began when the B&O passed through in 1851. Swanton developed during the 1880s and early 20th century as one of the railroad's lumber shipping points in the county. This scene depicts the Swanton Post Office as it appeared on August 4, 1911. The sender writes, "Reached here last night and feeling fine, Lansdale."

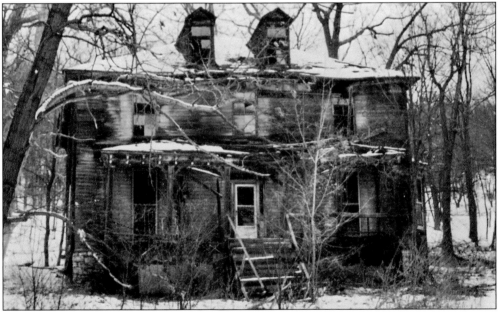

The old Swanton Hotel, or Lohr Boarding House as it was commonly known, is a Victorian style frame edifice constructed about 1880; it faces the B&O Railroad tracks. The Swanton Hotel accommodated the B&O Railroad telegraph operators and travelers unable to stay at the area's more luxurious hotels. Swanton was named in honor of Thomas Swann, who served as president of the B&O from 1849 to 1853. The hotel has deteriorated greatly since this 1991 winter depiction. (Author Photograph.)

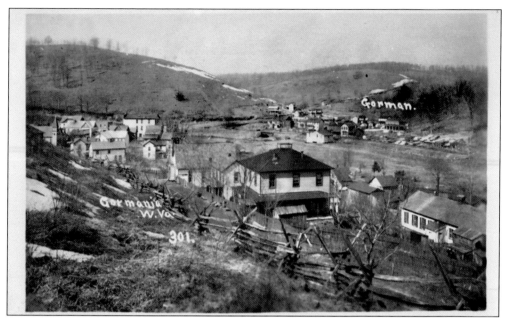

Gorman, Maryland, and its sister town across the Potomac River, Gormania, are both named after United States senator Arthur Pue Gorman of Maryland. Gorman was a stockholder in the West Virginia Central and Pittsburgh Railroad. This railway succeeded the old Potomac and Piedmont Railroad formed in 1866 by Congressman—and eventually U.S. Senator—Henry Gassaway Davis (1823–1916). The railroads' purpose was to develop the rich coal and timber resources of the Potomac Valley.

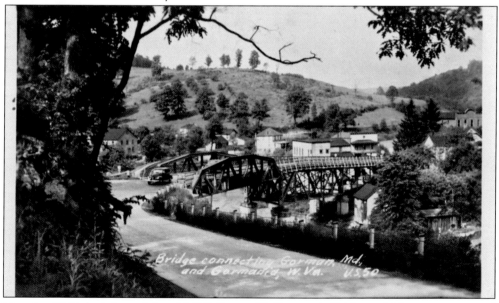

Here is a 1947 depiction of the old U.S. Route 50 Gormania Bridge, which was constructed in 1938 and crossed the Potomac River, connecting Gorman, Maryland, to Gormania, West Virginia. The small company towns along the railroad line were actually named after Senator Davis's colleagues, such as Senator Gorman, who were stockholders in the railroad, which was often referred to as the "Senatorial Railroad."

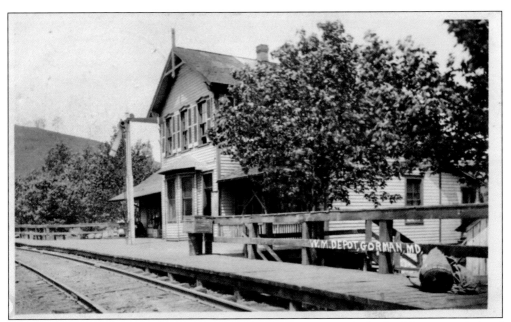

This photograph depicts the Western Maryland depot at Gorman. The back of this postcard, dated July 10, 1908, reads, "Miss Lula, Should you stop off for the night at this place and inquire for the Virginia Hotel you would meet me at the breakfast tomorrow. Preached here this evening. With best wishes, William." The West Virginia Central and Pittsburgh eventually merged into the Western Maryland system in 1905.

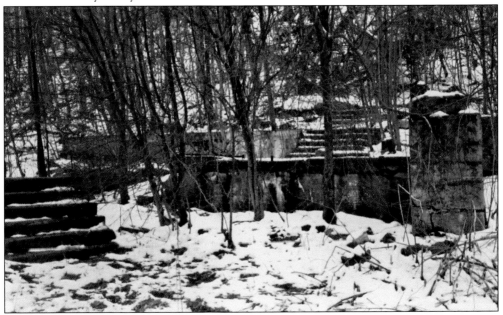

Vindex was once a thriving early-20th-century coal company town, which by 1920 boasted a school, a church, a company store, 75 homes, and 500 people. The last coal mine here would shut down in 1950. This 1991 photograph of East Vindex, along Three Forks Run, depicts the ruins of the company store and post office. The scene portrays a classic example of a coal town gone bust. (Author Photograph.)

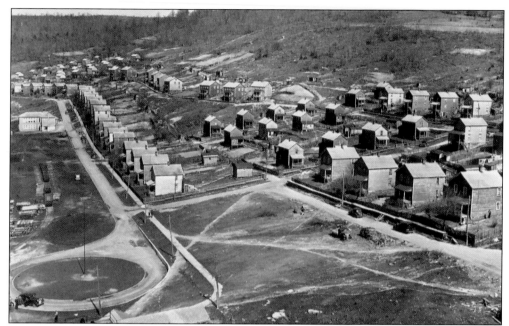

Kempton, located at the southwestern tip of Garrett County, was a coal town founded in 1912. It boasted over 850 residents; 106 frame, two-story homes; lights; paved streets; sidewalks; a movie theater; and school. The mine foremen lived on Front Street, and the workers, including immigrants, resided on the back streets along the mountainside. With the mine's closure in 1950, most of the jobs were lost. All that remains today are about a half dozen homes.

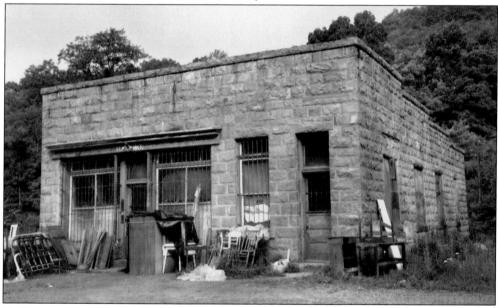

Shallmar is located below Kitzmiller on the North Branch of the Potomac River. Coal mining operations began here in 1917. The company store was constructed in 1920 or 1921. It was built of locally cut stone laid by Italian workers brought into Garrett County. The door on the right led to the pay office, while the door on the left opened into the company store and post office. The store closed about 1948. (Author Photograph.)

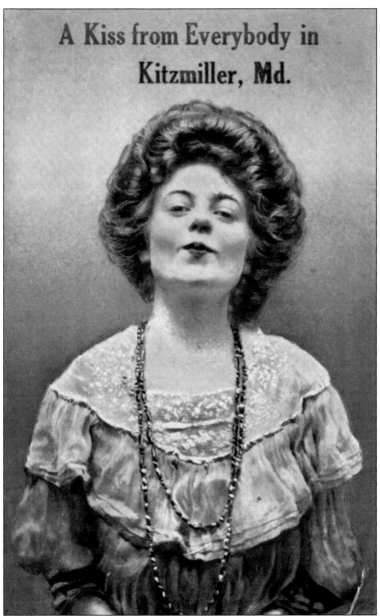

A Kiss from Everybody in Kitzmiller, Md.

The Town of Kitzmiller was incorporated in 1906 and is located just across the Potomac River from Blaine, West Virginia. Thomas Wilson settled in the area in 1801 and established a gristmill the following year. The town name, at one time Kitzmillerville and later Kitzmiller, comes from Ebenezer Kitzmiller, who married Thomas Wilson's daughter, Emily. Ebenezer also founded a woolen mill and shirt factory here in 1853, and even had the town named after him upon the establishment of a post office in 1877. Construction in the early 1880s of the railroad, which parallels the river on the opposite side from Kitzmiller in West Virginia, marked the beginning of Kitzmiller's era as a lumber town, with the mining and transport of coal beginning about 1897. As this 1912 postcard says, "A Kiss from Everybody in Kitzmiller, Maryland." The back reads, "Miss Gertie, Hello Kid! How are you? We sure are having some fine weather here. A friend."

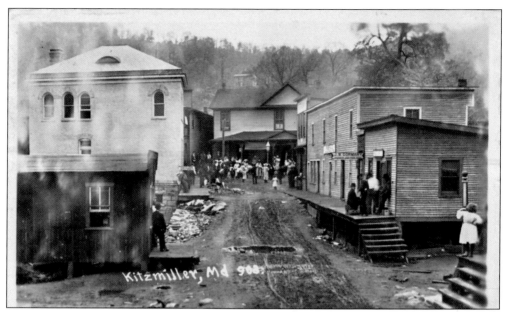

This is Union Street in Kitzmiller from a postcard dated July 28, 1908. The sender writes, "I can't get no postcard of the whole town at present. But will send you one soon. See you soon, Henry." The post office is on the right, while just next door is the J. B. Cormany harness and shoe shop. The town band, in the background, was giving a concert this day. Perhaps it was July Fourth.

Along with mining tragedies, the disastrous flood of March 29, 1924, washed out the Potomac Valley, (Pee Vee) Coal Company, which had opened in 1907, and nearly destroyed the rest of Kitzmiller. In the middle of this photograph stands the old Blaine, West Virginia, railroad depot, while in the background stands Kitzmiller's movie emporium, the Maryland Theater, razed as part of the flood control construction effort.

Four

DEEP CREEK LAKE
Maryland's Best-Kept Secret

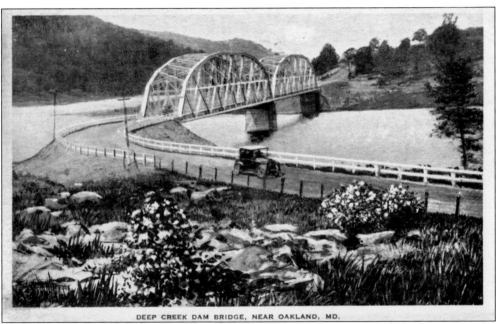

DEEP CREEK DAM BRIDGE, NEAR OAKLAND, MD.

In 1921, the Youghiogheny Hydro-Electric Corporation, a subsidiary of the Pennsylvania Electric Corporation of Johnstown, was granted the right by Maryland "to investigate the possibilities of utilizing the Youghiogheny River and its tributaries [Deep Creek] for the purpose of generating electricity." By 1923, the company had acquired almost 8,000 acres of land and 140 farms. Sales ranged from $5 to $2,500 an acre, with an average price of $55 per acre. Construction began on the dam in 1923, and the lake began to fill on January 16, 1925. Now owned by the state of Maryland, the lake has a shoreline of approximately 65 miles and a lake surface area of over 3,900 acres. At an elevation of 2,462 feet, the lake has a summer surface temperature of 73 degrees and an approximate mid-winter ice depth of 18 inches. The average depth is about 27 feet, and the maximum depth is 72 feet. This photograph is postmarked August 17, 1928, and depicts the old Route 219 Deep Creek Dam Lake Bridge.

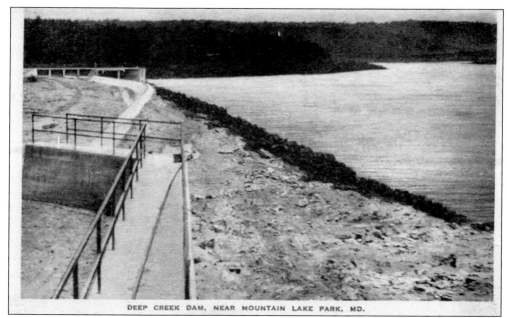

DEEP CREEK DAM, NEAR MOUNTAIN LAKE PARK, MD.

Construction began on the Deep Creek Dam on November 1, 1923. Twelve miles of railroad were constructed from the B&O at Oakland to the dam and powerhouse sites for the movement of equipment and supplies. Almost 1,000 men were employed in the early stages of construction. Fifteen miles of road and two bridges were relocated and constructed over the lake. The lake began to fill on January 16, 1925, with dam operations initiated on May 26, 1925.

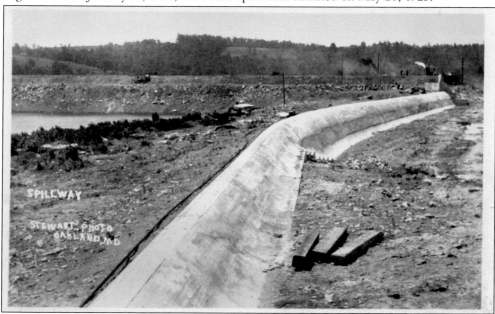

The dam, 1,340 feet long and 86 feet high from bedrock to the top of the dam, created a lake 13 miles long with a shoreline of almost 65 miles, and an area covering almost 4,000 acres. The spillway is depicted in this photograph under construction. The elevation or crest of water at the top of the spillway wall is 2,462 feet. The Deep Creek Dam had cost more than $9 million to construct.

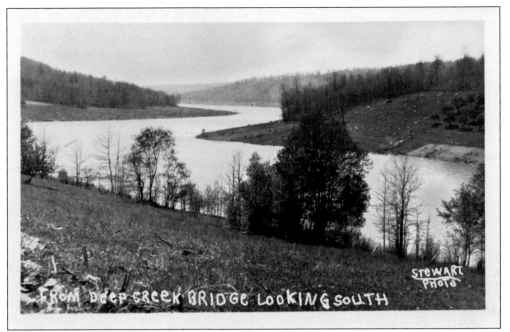

This Stewart Photo postcard depicts the lake looking south from the Deep Creek Lake Bridge. Deep Creek was purchased in 1942 by the Pennsylvania Electric Company, with the state of Maryland leasing and managing the buffer strip and lake. In early 2000, the state of Maryland officially agreed to purchase the lake and adjoining properties for $17.6 million.

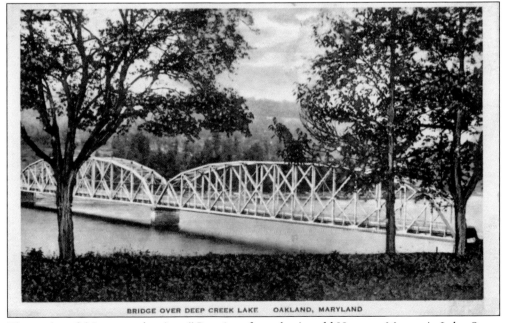

The sender of this postcard writes, "Greetings from the Arnold House at Mountain Lake. Sorry I did not get to see you before I left. Doctor advised my coming here. I have been sick all spring. It is about 2,600 feet here, a beautiful spot, and I hope to get well. There will be a school of Missions beginning July 10—Love, Mary. P.S. This is a scene near here."

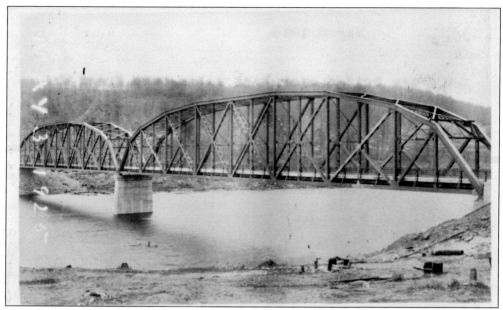

The Deep Creek Bridge was fabricated in 1924 by Bethlehem Steel of Pennsylvania for the Pennsylvania Electric Company. Its installation followed the damming of Deep Creek Lake in 1925. In 1986–1987, a new bridge was constructed to carry U.S. Route 219 across the lake. The old Deep Creek Lake Bridge was removed during the summer of 1987. This photograph, taken on Sunday, May 3, 1925, depicts what the photographer identifies as "the new bridge over back water Deep Creek dam."

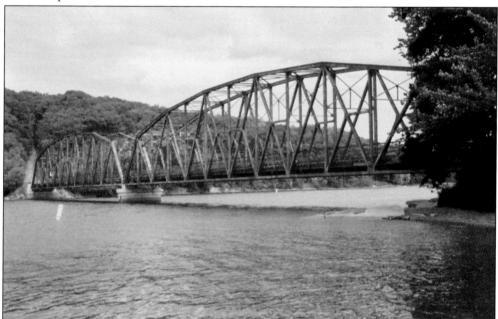

The old Glendale "Camelback" Bridge across Deep Creek Lake, as seen in this 1991 photograph, was a double-span, steel-mesh deck bridge constructed by the McClintic-Marshall Company of Pittsburgh in 1924. The old one-lane Glendale Bridge across Deep Creek Lake was approximately 14 feet wide and 512 feet in length. A new Glendale Bridge replaced it in 1997. (Author Photograph.)

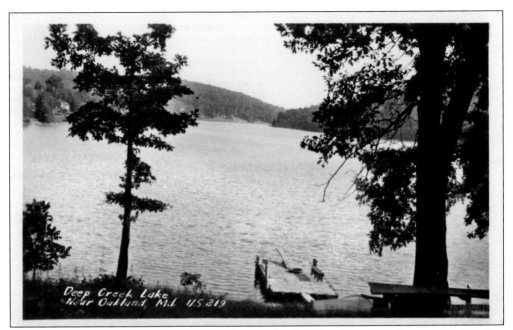

As the photograph states, this is a view of Deep Creek Lake along U.S. Route 219. This has been a familiar scene on the lake for almost 80 years: a diving board, a bench, and an inner tube. The 4,000-acre Deep Creek Lake is Maryland's largest freshwater lake ecosystem with more than 70 miles of shoreline. It is owned by the state and managed by the Maryland Department of Natural Resources.

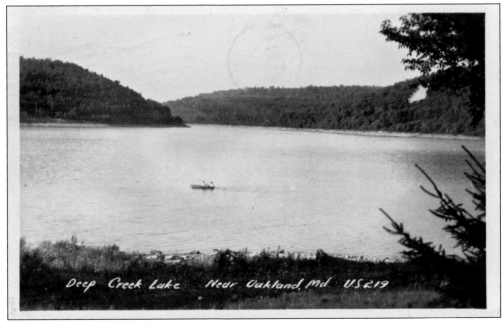

The sender of this August 6, 1946, postcard writes, "Dear Frances, We are way up in Garrett County, Western Maryland. I think you could hardly say we are in Maryland. We're very near several other States. I think we will only be here several days. We like it here because there is fishing, boating, and swimming. Keep track of the girls' wins and ballgame scores. Marion."

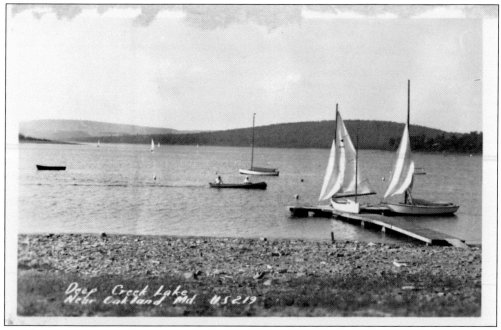

Another popular pastime, sailing, is depicted in the above photograph.

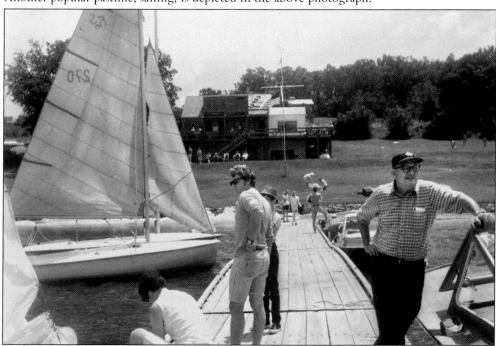

This Ruthvan Morrow photograph is from the early 1970s. On the left is one of the famous Flying Scot sailboats, number 270. The boat was first designed and built by Gordon "Sandy" Douglass in 1957. The Gordon Douglass Boat Company moved to Garrett County in 1958. With almost 50 years of production experience in Garrett County, and now known as Flying Scot, Inc., the Flying Scot remains a leading one-design class in the nation. In the background stands the Deep Creek Yacht Club–Turkey Neck, which was founded in 1937.

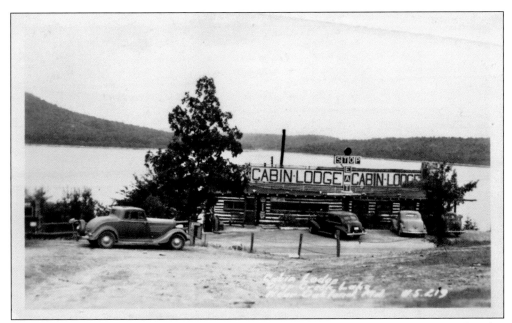

"Stop and Eat" at Cabin Lodge was a well-known and popular eatery on Deep Creek Lake. Cabin Lodge, as seen here in the 1940s, was located on U.S. Route 219 on the shores of beautiful Deep Creek Lake. The fireside dining room was open year round. "There's always something cooking at Cabin Lodge." This Deep Creek Lake landmark burned down in about 1962. One wonders what the temperature was on that old Mail Pouch thermometer.

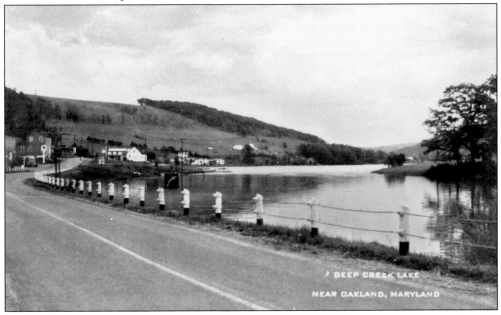

This is the state highway at McHenry as it looked in the 1950s. Dr. James McHenry of Baltimore served as an aide to Gen. George Washington during the Revolutionary War and also served as a secretary of war. The historic Fort McHenry in Baltimore is named in his honor. McHenry vacationed in this area and between 1805 and 1810 purchased several large tracts of land. Family members went on to reside here, and the community that followed takes his family name.

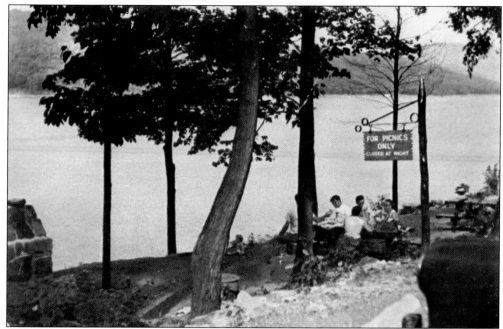

It's the 1950s, and shown is a picnic grove at beautiful Deep Creek Lake. Roadside picnic areas dotted the shoreline and were available without charge to passing motorists. The back of this postcard urges visitors to write the Promotion Council in Oakland for more information.

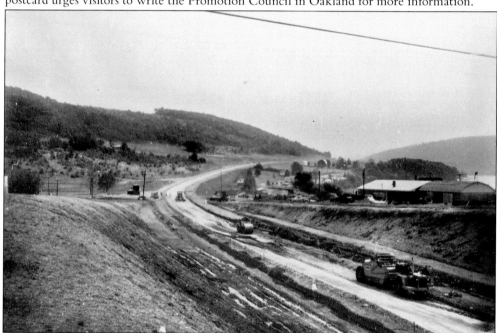

This photograph depicts the construction of Route 219 South, adjacent to Deep Creek Lake. Roadwork and construction of Route 219 occurred here between 1961 and 1965. The publisher of this and numerous other postcards in this book was Ruthvan W. Morrow Jr. (1914–1997). Morrow was not only a well-known photographer and postcard publisher but also farmed, ministered, and taught at both Northern and Southern High Schools. (Ruthvan Morrow Photograph.)

Here is the Will O' the Wisp Motel as it appeared on a postcard dated June 24, 1955. The sender of this postcard writes, "Well here we are after waiting all these long months since last year. It's as nice as ever. Plenty of fishing and swimming. See you soon. Ruth and Dutch. P.S. Dutch has a boat rental for the stay."

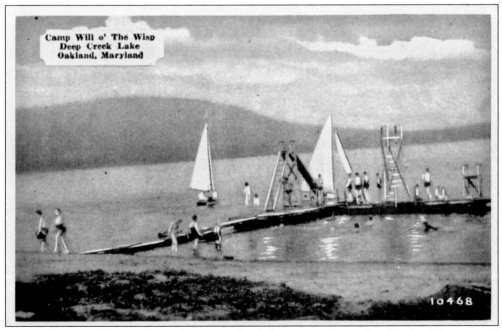

This early 1950s photograph is of Camp Will O' the Wisp at Deep Creek Lake. The postcard was published by the J. W. Jackson Company of Oakland.

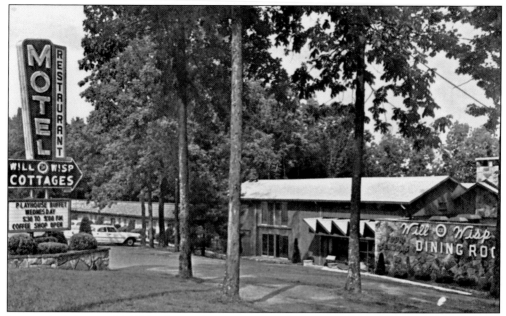

Postmarked August 17, 1970, the Ruthvan Morrow photograph above depicts the Will O' the Wisp Resort. The resort is advertised as "the most complete vacation spot on beautiful Deep Creek Lake. Motels, cottages, dining room and complete line of recreational facilities. Try our Playhouse buffet, every Wednesday. Your host, Mr. and Mrs. Helmuth Heise." The Heises purchased Will O' the Wisp in 1943. At that time, it was simply a collection of summer cottages on the shore of the lake. The Heises added a small hotel and restaurant. The back of the card reads, "Well, here we are after waiting all these long months since last year. It's as nice as ever. Beautiful day today. The Terrys."

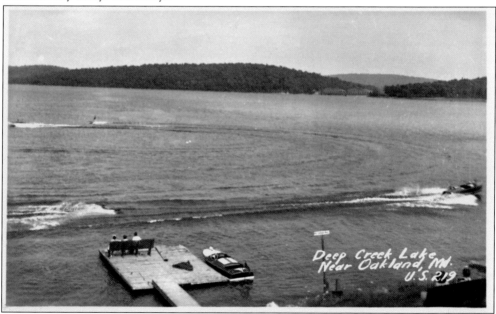

This photograph Deep Creek Lake along U.S. 219 could best be labeled "sitting on the dock of the lake."

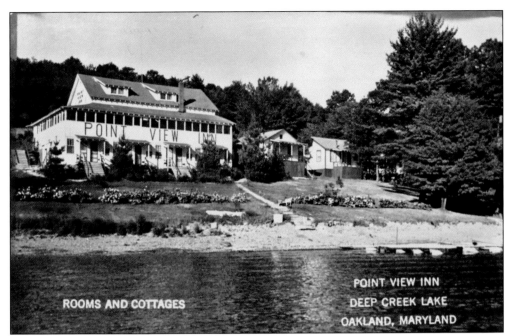

The Point View Inn is one of the earliest and still extant businesses on Deep Creek Lake, and, as this photograph from the 1950s shows, it has long been a popular destination point for those tourists seeking rooms or handsome cottages. The current Point View Inn facility was constructed during the spring of 1973.

This McHenry scene is from sometime between 1940 and 1942. It is taken from the Arden Boat Club looking across the lake to Route 219. The point of land on the left side of the picture is where the Deep Creek Lodge stood for many years. The present-day Wisp Resort would be behind the photographer.

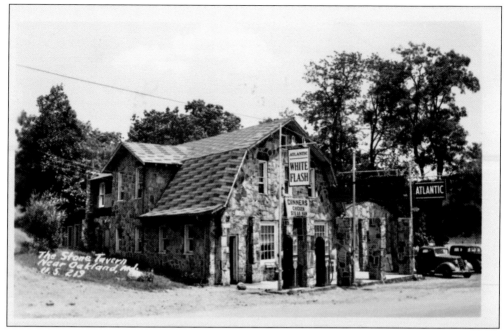

The old Stone Tavern depicted above was constructed in 1932 by C. M. Railey at the height of the Depression and is considered to be the first commercial restaurant on Deep Creek Lake. The tavern underwent several expansions and featured dining, dancing, and about 10 rooms for visitors and transients. The Stone Tavern, which stood at the Deep Creek Lake Bridge, was razed in 1969 for the widening of Route 219. As seen in this photograph from about 1937, the tavern featured chicken, steak, and ham dinners as well as Atlantic White Flash gasoline.

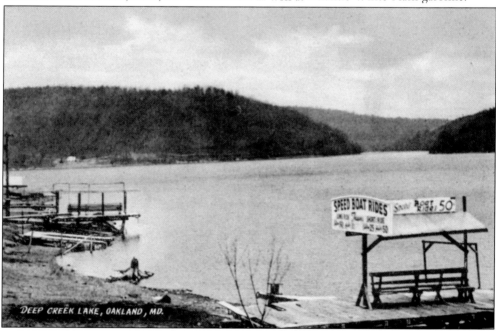

As seen in this photograph, once upon a time, speed boat rides were just 50¢ on Deep Creek Lake.

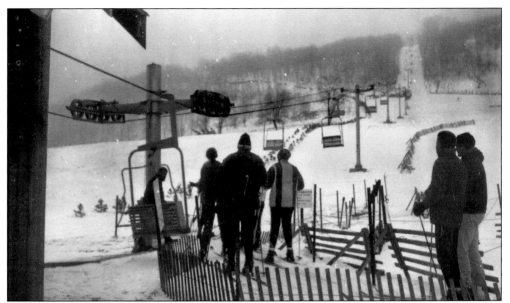

It was in 1955 that Helmuth Heise and several businessmen began to transform Marsh Mountain, a cow pasture owned by a local farmer, into a makeshift ski area. Skis were rented from the back of Helmuth's pickup truck. In 1958, a lift was added to replace the original rope tow, and by 1959, only Heise held to the dream of developing the area as a winter resort. He operated the ski area alone. (Ruthvan Morrow Photograph.)

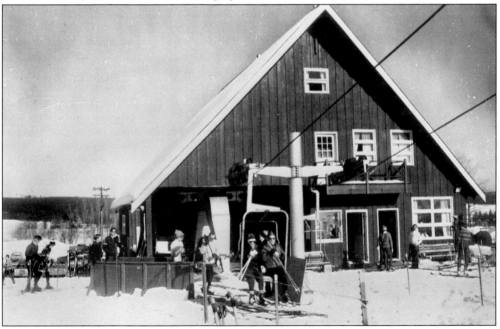

This photograph depicts what was known as the Eagle's Nest. The nest served as a 38-bed dormitory primarily used by youth groups. It was also the first-aid station and was located at the base of the No.1 double chair lift. Between 1959 and 1965, the Wisp developed into a bustling ski resort with a lodge continually expanding to handle the growing number of skiers. (Ruthvan Morrow Photograph.)

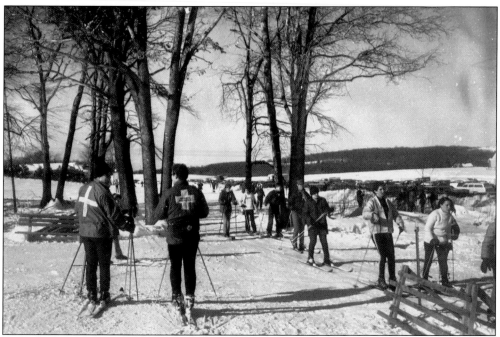

In 1971, the Village Inn motel was constructed at the base of the slopes near the ski lodge. Over the next eight years, more double chair lifts, slopes, and trails were added. Sold by Heise in 2001, the Wisp at Deep Creek Lake Mountain Resort is today a major four-season recreational complex far removed from 1955, when a one-room hut with a pot-bellied stove served as the ski lodge. Ski patrol members patrol the slopes in this early view. (Ruthvan Morrow Photograph.)

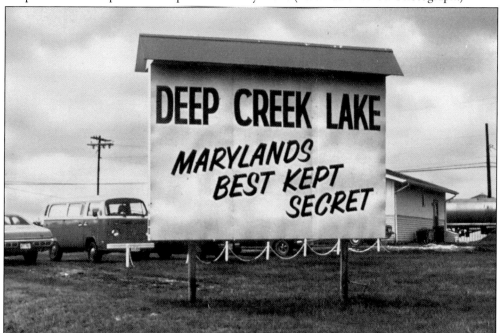

In the late 1970s and very early 1980s, this sign boasted of Deep Creek Lake as being "Maryland's Best Kept Secret." Obviously the sign has been gone for quite some time. (Author Photograph.)

Five

THE HISTORIC NATIONAL ROAD
The Road that Built the Nation

On June 10, 1755, British general Edward Braddock left Fort Cumberland on his march toward Fort Duquesne to take it from the French. The trail he used, Nemacolin's Path, was earlier used in 1753 and 1754 by George Washington to first warn, and then enforce, British demands upon the French to leave the Ohio Valley. Washington's defeat at Fort Necessity on July 3, 1754, initiated the French and Indian War. The Braddock expedition improved the path, developing it as a major route westward until the advent of the National Road. Braddock met defeat at the hands of the French and Indians at the battle of Monongahela on July 9, 1755. On July 13, Braddock died from his wounds and was buried on July 14, with George Washington delivering a eulogy. The trail he took to defeat became known as Braddock's Road. It is written Braddock's final words were, "We shall know better how to deal with them another time." Four encampment sites used during Braddock's march to Fort Duquesne are located within present-day Garrett County.

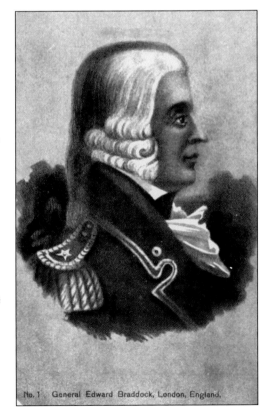

No. 1 General Edward Braddock, London, England.

No. 16 Camp on Henry Blocher farm, Little Savage Mt., west of Frostburg, Md.

Photo copyright, 1908, by E. K. Weller.

The Savage River Camp was located on the western slope of Little Savage Mountain. This was Braddock's third camp on the march to Fort Duquesne, June 15, 1755. The route, later known as the Old Braddock Road, passed to the southeast of the National Road. Robert Orme, a captain in Braddock's army, wrote in his diary, "We entirely demolished three wagons and shattered several" descending Savage Mountain. (E. K. Weller Photograph.)

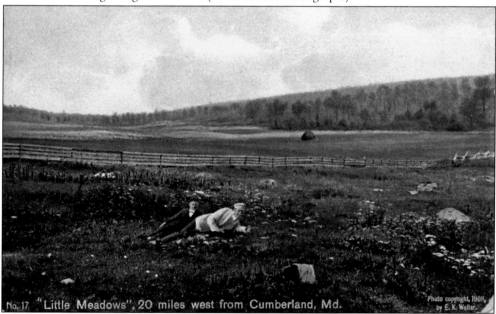

No. 17 "Little Meadows", 20 miles west from Cumberland, Md.

Photo copyright, 1908, by E. K. Weller.

Little Meadows was Braddock's fourth camp on June 17, 1755. Here during a council of war, it was determined that General Braddock and a detachment of 1,200 "lightly encumbered" regulars would move forward while the remaining force would advance slowly with the heavy baggage, stores, and artillery. George Washington arrived back here on July 15 after Braddock's defeat and burial. (E. K. Weller Photograph.)

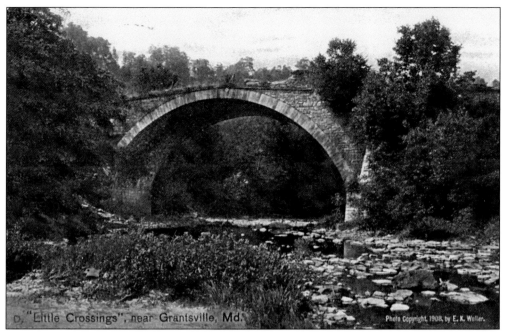

D. "Little Crossings", near Grantsville, Md. Photo Copyright, 1908, by E. K. Weller.

The fifth encampment was located about two miles west of Little Crossings. Little Crossings received its name from George Washington when he crossed the Little Youghiogheny, now called the Casselman River, on June 19, 1755, with Gen. Edward Braddock on the march to Fort Duquesne. (E. K. Weller Photograph.)

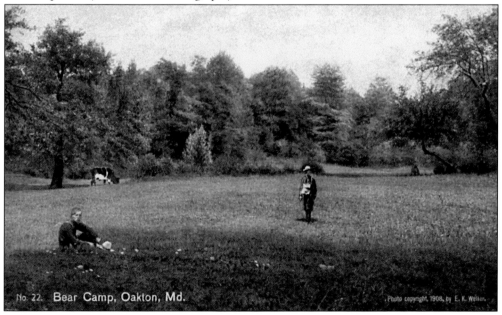

No. 22. Bear Camp, Oakton, Md. Photo copyright, 1908, by E. K. Weller.

On June 20 and 21, 1755, Braddock's made his sixth encampment, Bear Camp. Washington was forced to stay behind for a time at the next encampment with "violent fevers." These were cured by Dr. James' Powders, which, according to Washington, was "one of the most excellent medicines in the world." Bear Camp was located nine miles from the previous camp and a half mile south of the Maryland-Pennsylvania boundary at Oakton. (E. K. Weller Photograph.)

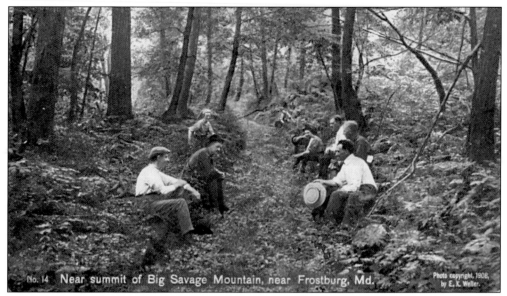

No. 14 Near summit of Big Savage Mountain, near Frostburg, Md. Photo copyright, 1908, by E. K. Weller.

These Braddock Road postcards are the work of Ernest K. Weller, a photographer who accompanied and photographed Prof. John Kennedy Lacock's 1908 and 1909 expeditions retracing Braddock's 1755 march. This scene depicts the party on the eastern slope and near the summit of Big Savage Mountain. "The ascent is rocky and steep in many places. On the western slope flows the Big Savage River. The descent is rugged and almost perpendicular at places." (E. K. Weller Photograph.)

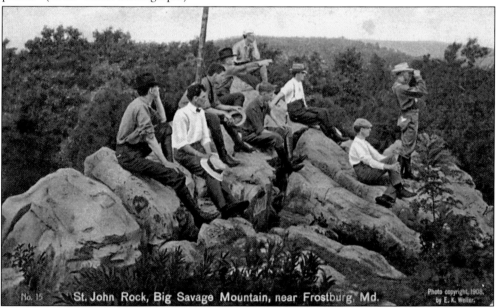

No. 15 St. John Rock, Big Savage Mountain, near Frostburg, Md. Photo copyright, 1908, by E. K. Weller.

This is the Lacock expedition on St. John's Rock, Big Savage Mountain, elevation 2,900 feet and about one-quarter mile northwest of Braddock's Road. The rock is felt to be named for Sir John St. Clair, a lieutenant colonel in the 22nd regiment who had been assigned as deputy quartermaster-general for all British forces in America, and who accompanied Braddock on the march. Such lookouts were popular in the late 19th century and were visited by travelers. (E. K. Weller Photograph.)

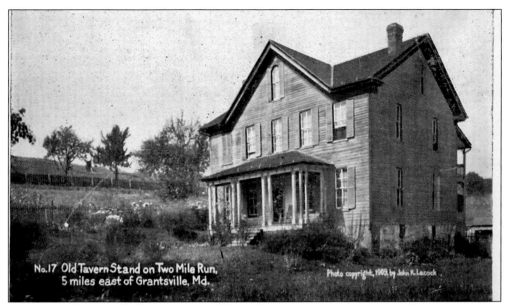

No.17 Old Tavern Stand on Two Mile Run,
5 miles east of Grantsville, Md.

Photo copyright, 1909, by John K. Lacock

This is the Old Tavern Stand on Two Mile Run, five miles east of Grantsville. The tavern stood in an area known as Shades of Death, the most dreaded passage on the old Braddock Road, now Route 40. Dense forest of white pine once covered this region and gave favorable shelter to highwaymen robbing stagecoaches and murdering travelers along the National Road. This 1909 view depicts a farmhouse that later became part of Turner's Dairy. It was razed in August 1990. (E. K. Weller Photograph.)

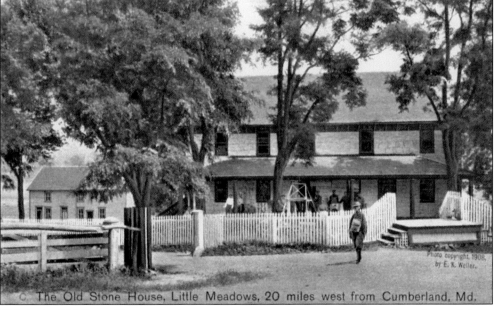

Photo copyright, 1908, by E. K. Weller.

The Old Stone House, Little Meadows, 20 miles west from Cumberland, Md.

This is the Old Stone House, also known as Tomlinson's Inn at Little Meadows. Located three miles east of Grantsville, the inn was constructed along the National Road about 1818. Built by Jesse Tomlinson, a well-known postmaster and state legislator, the inn served the National Road between 1820 and 1850, when stagecoach and freight traffic was at its heaviest. It also hosted James K. Polk in 1845 on the way to his presidential inauguration. (E. K. Weller Photograph.)

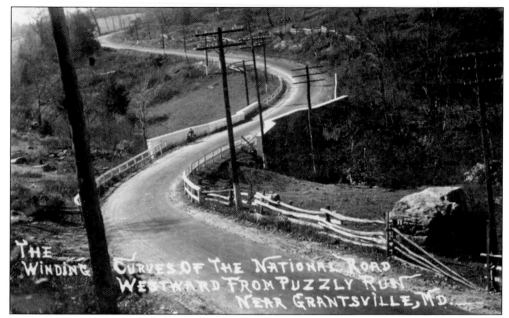

Several of the National Road postcards appearing here are the historic and creative legacy of Leo J. Beachy (1892–1927). Crippled from the age of fourteen, Beachy lived his entire life in the Grantsville area at the family homestead, Mount Nebo, which was also the name of the photographic studio he built upon the family grounds. This scene depicts the road's "winding curves westward from Puzzly Run near Grantsville." (L. J. Beachy Photograph.)

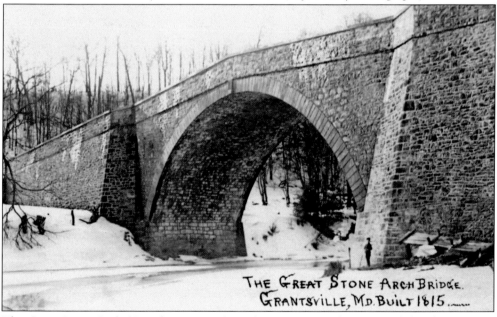

The Great Stone Arch (Casselman River) Bridge, as seen in this postcard dated 1920, was constructed between 1813 and 1815. The Casselman River Bridge has an 80-foot span and was at the time of its construction the largest single-span stone arch bridge in America. David Shriver Jr., superintendent of the National Road, built the Casselman River Bridge. Skeptics felt the arch would collapse once the supporting timbers were removed. (L. J. Beachy Photograph.)

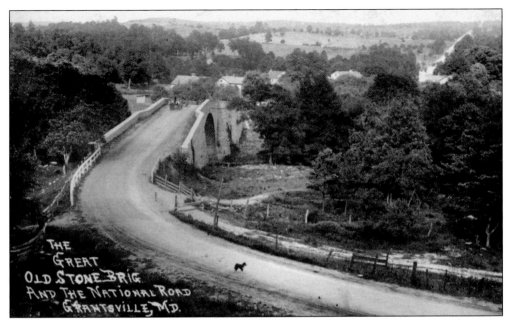

As legend has it, Superintendent Shriver had the key supporting structure quietly removed the night before the public opening. He stood beneath the arch and proclaimed that he might as well be dead if the bridge failed. The bridge served as a major link along the National Road from 1813 to 1933, when a new steel truss bridge was erected on U.S. Route 40. The Casselman River Bridge was closed to vehicular traffic about 1953. (L. J. Beachy Photograph.)

In 1785, Pres. George Washington advocated the development of the Braddock Road into a national highway. In 1806, Congress authorized the Cumberland, or National, Road to be built from Cumberland, Maryland, to the Ohio River. That same year, Pres. Thomas Jefferson appropriated $30,000 for survey work. Construction began at Cumberland in 1811, with the road completed to the Ohio at Wheeling by 1818. This scene shows "the bend in Road near the Great Old Stone Bridge." (L. J. Beachy Photograph.)

By 1840, the National Road had reached Vandalia, Illinois. In the 1920s, a national system of highways and numbering was initiated, and by 1926 the road became part of U.S. Route 40. In June 2002, the 824-mile "Historic National Road," from Baltimore, through Cumberland, the National Road's point of origin, to its terminus at Vandalia, was officially designated one of our nation's All-American roads. This 1940s postcard depicts the "National Highway, U.S. 40 west of Grantsville."

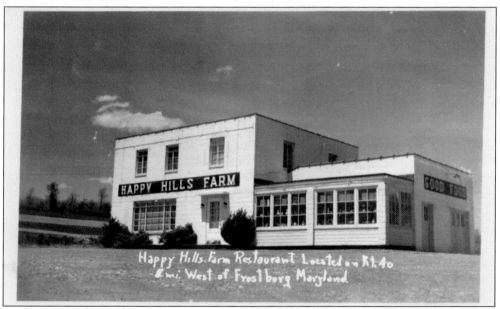

In 1965, construction of the National Freeway, then designated Route 48, was initiated. Between 1974 and 1976, the Garrett County portion of the freeway had been completed and opened. This 1950s photograph depicts the Happy Hills Farm Restaurant, five miles west of Frostburg on U.S. Route 40. Established by John Hafer Sr. and earlier known as the Farmer Market, Happy Hills featured home-dressed meats and good food. By the way, folks, they had ice cream and souvenirs too!

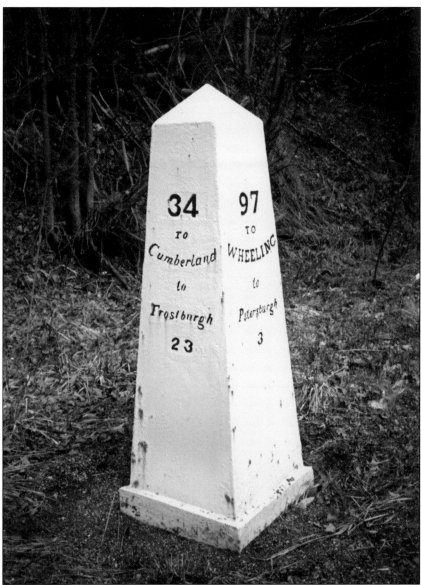

These white cast-iron mileposts were placed along the National Road between Cumberland and Wheeling in 1835, when the states took over the responsibility of maintaining the road. Sources vary with Maryland assuming final responsibility for its portion sometime between 1832 in 1836. Upon the charging of tolls, the National Road began to be referred to as the National Pike. This referred to the pike that stretched across the road at the tollhouse locations and was turned to let travelers pass through upon paying the toll, thus the term turnpike. Those who tried to avoid the toll were called pikers. The expression, "Sleep tight, don't let the bed bugs bite," came from travelers staying overnight at the stagecoach stops or tavern stands who often had to tighten the rope beds and brush the bugs off the sheets. These mileposts replaced the original milestones, which had become damaged and broken. There were 133 mileposts originally, quite a few of which still stand in Maryland. They told the traveler how far it was to the next town, how far along on the National Road he had come, and how many miles to the end. (Author Photograph.)

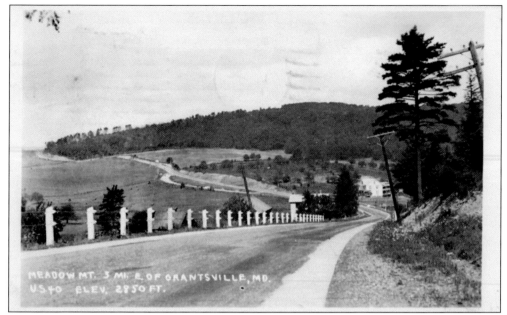

On August 2, 1991, with the final "missing link" in Allegany County completed, Maryland governor William Donald Schaefer announced the opening of Interstate 68, successor to Route 48, which succeeded Route 40, which succeeded the National Road, which succeeded Braddock's Trail, which succeeded Nemacolin's Path. This 1934 view of Route 40 depicts Meadow Mountain, three miles east of Grantsville, elevation 2,850 feet. The sender writes, "Having a good trip. Wish you could enjoy it too."

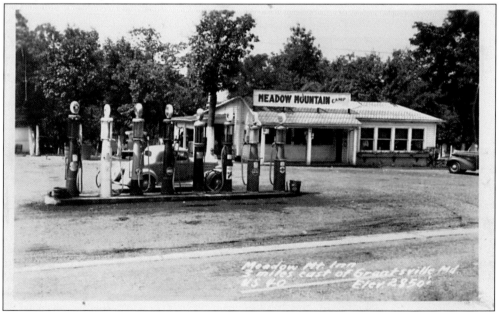

This is a great 1940s scene of the Meadow Mountain camp on U.S. Route 40, three miles east of Grantsville, elevation 2,850 feet. Talk about your choices of gasoline. Among the brands are Sinclair HC, Amoco, Gulf No-Nox, Fire-Chief, American, and Sunoco. The U.S. Geological Survey actually lists the summit of Meadow Mountain itself at 3,020 feet.

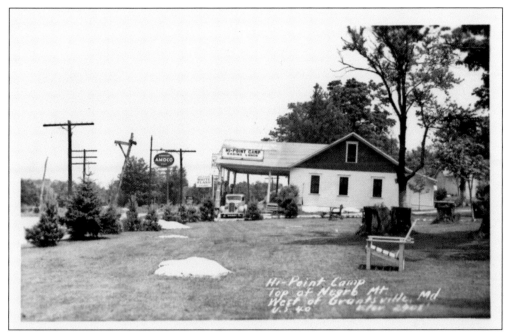

Located 28 miles west of Cumberland on U.S. Route 40 was the High Point Camp. The camp was located atop Negro Mountain and, at an elevation of 2,908 feet, was advertised as being the "Highest Point on the National Trail." Here the traveler could eat lunch, fill up with Amoco or Atlantic White Flash gasoline, and, as advertised in this mid-1940s depiction, could even rent a cottage for the night.

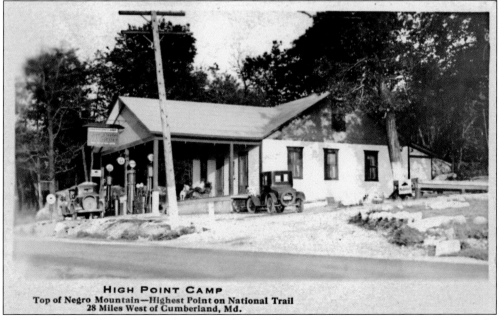

Here is a much earlier pre-1920 depiction of the High Point Camp atop Negro Mountain. The U.S. Geological Survey lists the summit of Negro Mountain in Maryland at 3,075 feet.

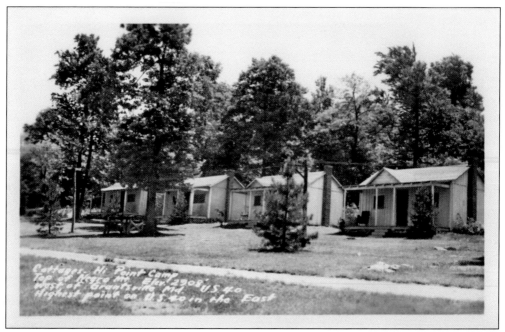

This postcard is from about the 1940s. It depicts the Hi-Point cottages on top of Negro Mountain. Auto-Camps, cabins, and cottages such as this served the traveler and were common along U.S. Route 40. The site is billed as "the highest point on U.S. 40 in the East," elevation 2,908 feet.

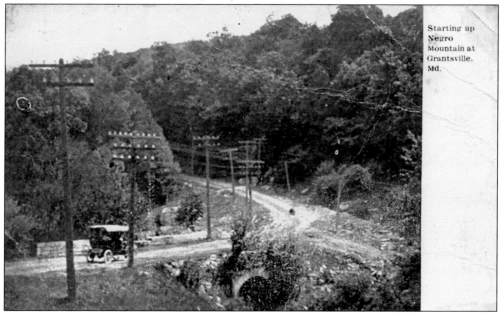

Starting up Negro Mountain at Grantsville. Md.

The sender of this August 1915 postcard writes, "We are now at Camp Castleman and having a jolly time." The most commonly accepted historical account as to how Negro Mountain received its name can be traced to the 1750s. Col. Thomas Cresap and his black "body-servant" (slave), Nemesis, were tracking a group of American Indians who some say had attacked a settlement near present-day Oldtown in Allegany County. It was said a family had been murdered and horses stolen.

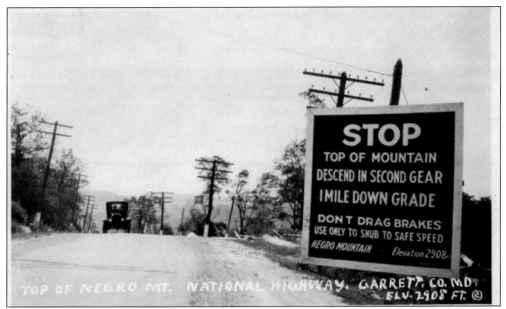

Others write Nemesis was requested to accompany a ranging party that regularly scouted the frontier to protect homes from attack. Either way, Nemesis had a premonition he would not return. One evening while cleaning his weapon, Nemesis told Cresap that he would not be coming back. Cresap thought Nemesis was afraid or going to run away. He offered Nemesis the opportunity to remain behind if he was scared. Nemesis replied he was not scared, simply stating a fact.

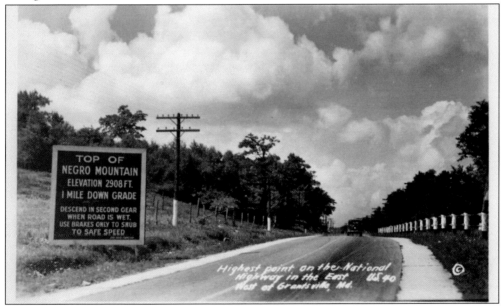

Cresap's party pursued the Indians over present-day Savage and Meadow Mountains to the next mountain, where a fierce battle ensured. Nemesis fought bravely, was killed, and was buried on the site. Cresap named the mountain in honor of Nemesis's race, and it has ever since been known as Negro Mountain. Nemesis was said to be a large and powerfully built man. Negro Mountain remains a memorial to the presence of this black frontiersman.

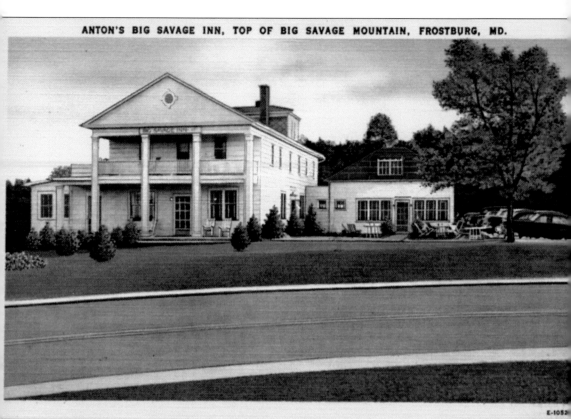

E-1052

Anton's Big Savage Inn was located two miles west of Frostburg on U.S Route 40. The back of the card notes that the inn is delightfully cool in the summer, features a fireplace and steam heat, ample parking, and famous home-cooked meals. Just telephone Frostburg 884. The sender writes, "Rain, rain, rain but we don't care—inside is fine and plenty to eat—even a lot of candy. Love, Nana." Known as the Big Savage Hotel in earlier depictions, the hotel once boasted of having the "highest sleeping quarters on the National Highway east of the Mississippi River" and advertised itself as a modern "Stop Over Inn" for either rooms or meals—a delight resting place for the tired traveler. Anton's Big Savage Inn was destroyed by a fire in the 1970s. Where does the name Savage Mountain come from? In October 1736, 17 surveyors and explorers headed west from Virginia on a mission. They had been appointed by the king of England, George II, to survey the headwaters of the Potomac River and determine the boundary of Thomas, Lord Fairfax's land.

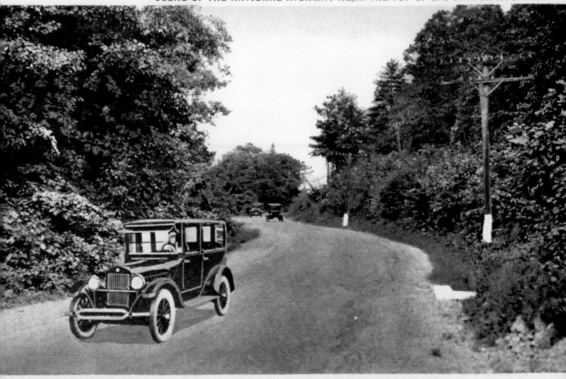

WEST OF FROSTBURG, MD. 104296

It was late in the year to begin such a journey. By December, the expedition had battled two snowstorms and exhausted their food supply. They were cold, starving, and camped at the mouth of a "raging river." It was at this point they began considering the killing and eating of "the most worthless member of their party." John Savage, a surveyor whose eyesight was failing, was the obvious choice. Some say he volunteered himself. Fortunately provisions arrived just in time, and Savage was spared. His companions, feeling remorseful, named the "raging river" flowing near their camp after their intended supper, hence, the "Savage River." The mountain soon took its name from the river. The surveying party went on to complete its mission before Christmas. The group then returned east. Most geological sources state Big Savage Mountain has an altitude at its summit of 2,991 to 3,000 feet.

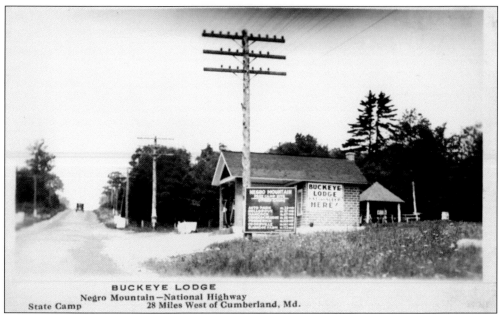

BUCKEYE LODGE
Negro Mountain—National Highway
State Camp 28 Miles West of Cumberland, Md.

"Eat and Sleep Here!" Free State campsites and food were always available in the 1920s at Negro Mountain's Buckeye Lodge. The lodge was located on the National Highway, 28 miles west of Cumberland, Maryland. Other auto-camps, such as Bellgrove, Hancock, Conococheague, Frederick, Cooksville, and Elkridge Farm, are listed on the billboard with the distances to each.

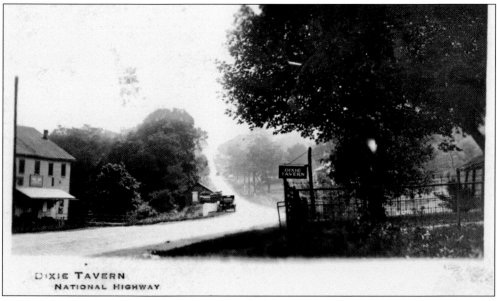

DIXIE TAVERN
NATIONAL HIGHWAY

On the left is the old Stanton Gristmill; on the right is the Dixie Tavern. The Dixie was originally known as the Little Crossings Inn and was constructed in 1818. It served up to 14 stagecoaches per day. It underwent several ownerships and in 1924 served as a hotel known as the Dixie Tavern. Later known as the Arlington, the site was acquired in 1959 by Penn Alps, and a major restoration was undertaken. The sender of this 1926 postcard writes, "Our first sleeping place. All went fine and we are well."

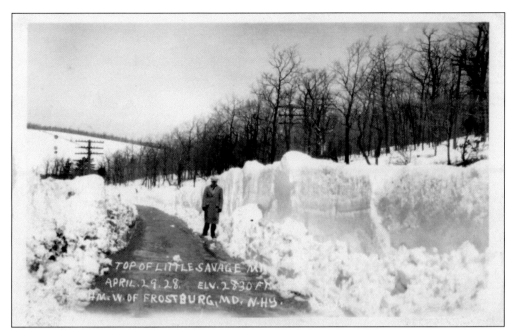

The above scene is of the top of Little Savage Mountain on the National Highway four miles west of Frostburg as seen during the late-spring snowstorm of April 29, 1928.

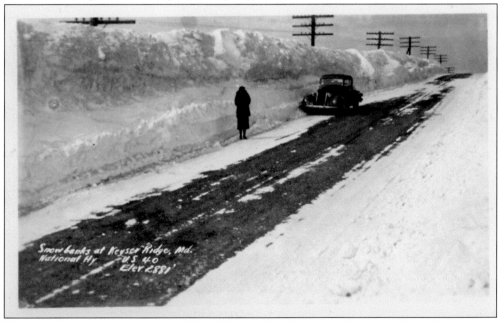

These snow banks once symbolized U.S. Route 40 at Keyser's Ridge, elevation 2,881 feet. It is written that forging through snowdrifts of 20 feet or more was not uncommon along the National Road. In 1921, the Federal Highway Act was passed to provide a federally funded system of primary routes. One of the earliest routes came into being by 1925–1926, when the old National Road became part of U.S. Route 40. In 1956, the Federal Aid (Interstate) Highway Act was passed, creating the interstate system. Interstate 68, which parallels much of the original National Road and U.S. Route 40 through Maryland, was officially dedicated on August 2, 1991.

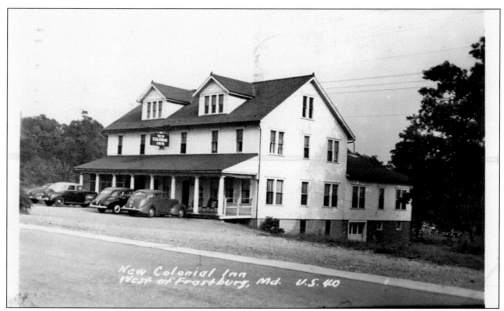

On September 19, 1949, the sender of this postcard from the New Colonial Inn writes, "Hello Sis: Remember this place where we had our good chicken supper? Been warm again today. Hope it stays pretty. Too soon for cold weather yet. We are going riding tonight. Love Chester." The inn was constructed in 1929 on U.S. Route 40 about five miles west of Frostburg. It serviced travelers with home-cooked meals, soups, pies, Esso gasoline, overnight cabins, a gift shop, and picnic grounds.

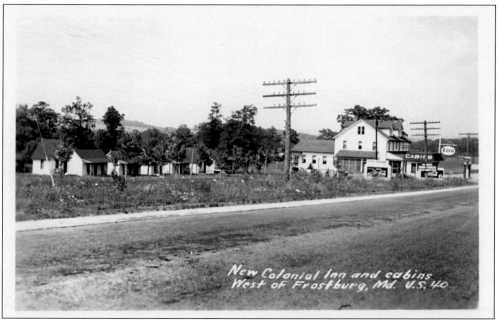

The inn was quite a popular place in the years following World War II but closed in 1957. The site then served as a Pentecostal church. The building was purchased in 1979 and opened as the Hen House West Restaurant the following year. The inn's cabins in this photograph served travelers along U.S. Route 40 and also those who later attended church camp meetings and revivals.

Six

LANDMARKS
From Einstein to Waterfalls

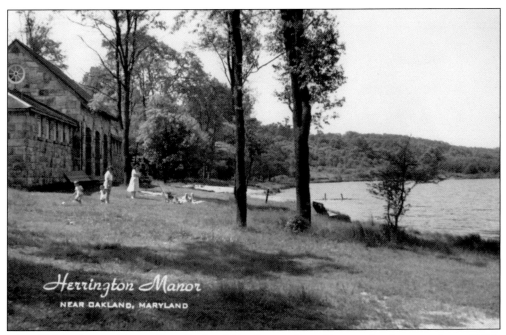

Herrington Manor
NEAR OAKLAND, MARYLAND

It is said Herrington Manor State Park within Garrett State Forest takes its name from Abijah Herrington, a Revolutionary War soldier who patrolled and settled here after the war. Development of a recreation area began with the aid of the Civilian Conservation Corps (CCC), one of the New Deal programs established by Pres. Franklin Roosevelt in 1933. Known as FDR's "tree army," these men did public improvements and conservation work across the country until 1942. A CCC camp located at nearby Swallow Falls built the 53-acre lake, earthen dam, and numerous cabins. The three-bay bathhouse depicted on the left, now a renovated concession stand, was also erected on the beach during this period and was constructed of local stone. Named for a manor house of which only the foundation remains, Herrington Manor was designated a state park in 1964. The sender of this August 1950 postcard writes, "We are really enjoying Herrington Manor, and are in cabin #13. There are 13 in our party, but we aren't superstitious. It's very cool at night. The kids went fishing but we haven't had a fish dinner yet. Yesterday we went to Swallow Falls for supper and today we had a weenie roast down at the picnic grove."

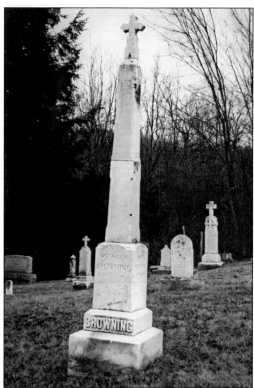

Meshach Browning was born in 1781 and died in 1859. He settled in an area generally known as the Sanging Ground, later called Sang Run. He authored a popular autobiography entitled *Forty-Four Years of the Life of a Hunter*. Browning, whose grave site is depicted in this photograph, was Maryland's most noted hunter, having killed over 2,000 deer and anywhere from "three to five hundred bear," as well as numerous panthers and wildcats. (Author Photograph.)

A sign along Interstate 68 atop of Meadow Mountain denotes the Eastern Continental Divide. All rainfall, runoff, streams, and rivers on the western side drain into the Youghiogheny, then to the Ohio and Mississippi Rivers and onto the Gulf of Mexico. Drainages on the east flow to the Potomac River to the Chesapeake Bay and the Atlantic Ocean. The Eastern Continental Divide actually snakes its way through Garrett County for 43 miles. (Author Photograph.)

Muddy Creek Falls,
Mountain Lake Park, Md.

The sender of the above 1912 Muddy Creek Falls postcard writes, "This is so much preferred to bible study and classes. So cool and delightful and everybody's happy. Come join us. Tess." Muddy Creek Falls is located within Swallow Falls State Park, and at 54 feet (some sources place it as high as 63 feet) is the largest free-falling waterfall in Maryland. The creek has its source in the Cranesville Swamp and gets its name from the brackish waters found there. Muddy Creek empties into the Youghiogheny River.

Yough River from County Bridge, Oakland, Md.

This is the Youghiogheny River from a postcard dated July 25, 1911, and viewed from the county bridge in Oakland. The sender writes, "It is so nice here. Ed and I slept under a blanket last night and I have been resting all day. With love to all, Wilma." "Youghiogheny" is a Shawnee word meaning "river that flows in a contrary direction."

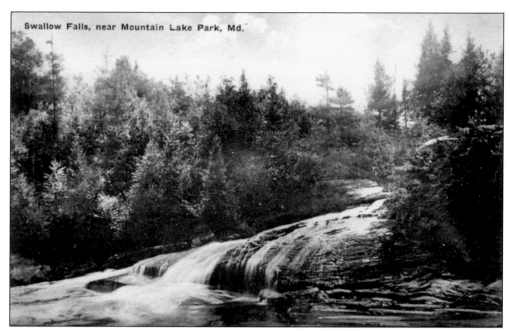

Swallow Falls, near Mountain Lake Park, Md.

As legend has it, Swallow Falls, depicted in 1908, received its name from pioneer days, when great flocks of cliff swallows dwelled here. Famous campers include Henry Ford, Thomas Edison, Harvey Firestone, and naturalist John Burroughs. Maryland's forestry program began here in 1906 when two brothers from Baltimore, John and Robert Garrett, grandsons of John W. Garrett, donated nearly 2,000 acres of forest to the state with the stipulation that Maryland "would take care of it." The donation was later combined with other tracts to form Garrett State Forest.

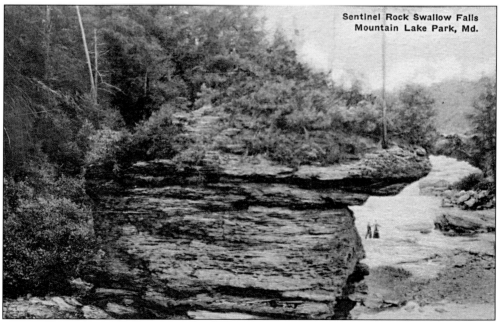

Sentinel Rock Swallow Falls
Mountain Lake Park, Md.

The sender of this early-20th-century depiction of Sentinel Rock at Swallow Falls writes, "Bess, We drove over here this afternoon. We are having an excellent time. Never felt better in my life. Tom." Sentinel Rock was also sometimes referred to as the Devil's Tea Table.

This winter scene of U.S. Route 50 is from a postcard dated December 30, 1950. It was sent to a gentleman in Houston, Texas. The back reads like a weather report from the sender, "17 degrees below zero on the 27th—13 degrees below zero on the 28th—only 53 inches of snow—Some winter. But with plenty of natural gas we enjoy it. Bill."

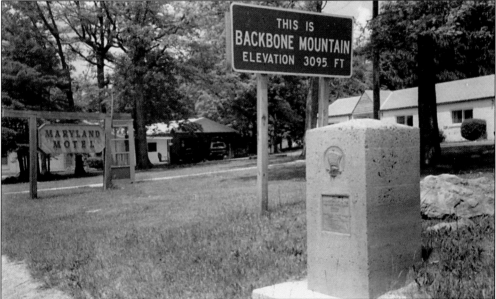

As the highway sign indicates, Backbone Mountain at this spot has an elevation of 3,095 feet. This highway monument on Route 50, between Red House and Gorman, was placed in 1928 by the Maryland State Roads Commission and identifies this spot as the "Highest Point on the Maryland State Roads System." At an elevation of 3,360 feet above sea level, Backbone Mountain's Hoye Crest, named for Garrett historian Charles Hoye, is the highest point in Maryland. (Author Photograph.)

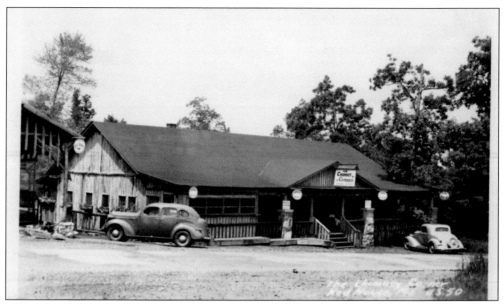

Chimney Corner, as seen in this late 1930s scene, was located near the intersection of U.S. Route 50 and U.S Route 219 at Red House. Chimney Corner was built in 1932 and opened in 1933 by Amos Peters. He purposely constructed it to convey a rustic image. This photograph advertises rest rooms in the rear, ice-cold beer and ale, T-bone steaks, country ham, fried chicken, and a first-aid station—which hopefully had nothing to do with the food.

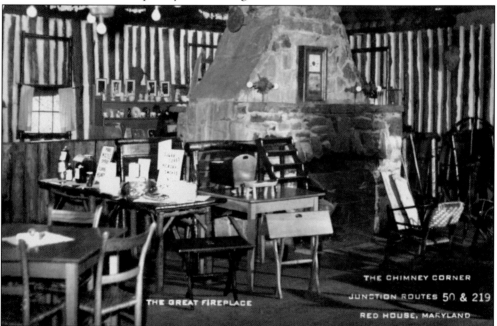

Open year round, Chimney Corner was a popular night spot because of its entertainment and dancing. In 1939, the emphasis began on food. Between 1942 and 1945, with food and gas rationing in effect during World War II, Chimney Corner was open mainly at night. Chimney Corner cured and hickory-smoked their own hams, bacon, and sausage, served with pure maple syrup and buckwheat cakes.

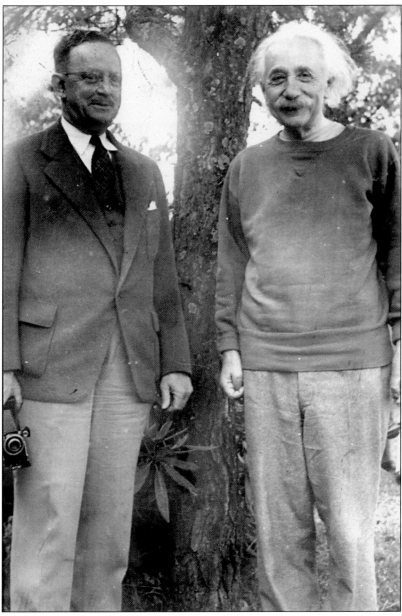

In September 1946, Dr. Albert Einstein (1879–1955) spent a two-week vacation on Deep Creek Lake at the summer home of Dr. Frank M. Wilson, who appears on the left of this photograph. As recalled by Blair Thompson of Cumberland who attended Einstein, the professor would read the *New York Times* as well as the Cumberland and Oakland newspapers, always stopped to chat with strangers on his walks around the lake, and enjoyed reading, sailing, meditating, and observing the wildlife. Einstein, it is said, was particularly fond of sitting on the porch before breakfast and gazing out into the distance beyond the lake, as well as sitting alone in front of the fireplace in the evening with his thoughts. Once in response to an invitation to attend services at Cumberland's B'er Chayim Temple, Einstein wrote, "Despite being something of a Jewish saint I have been absent from a synagogue for so long that I am afraid God would not recognize me and if He would it would be worse." (Collection of Rev. John A. Grant.)

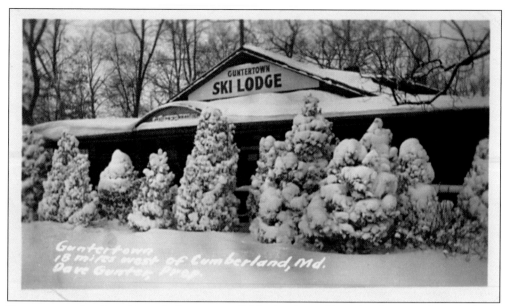

Do you remember Dave Gunter's Guntertown Ski Lodge, located just 18 miles west of Cumberland? Located just off U.S. Route 40, Guntertown's cottages were also a popular attraction and destination.

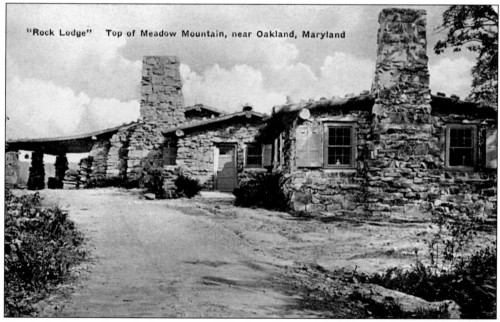

This is the famous Rock Lodge on top of Meadow Mountain. The lodge, about one and a half miles from Deep Creek Lake, is a one-story dwelling built of native sandstone. It was constructed in 1919 as the mountain retreat for Frank F. Nicola, a wealthy Pittsburgh businessman. Rock Lodge burned in 1928 but was rebuilt as identical as possible to the original structure. This photograph is from the early 1920s.

This is Eagle Rock, from a card dated September 3, 1912. Located about three and a half miles southeast of Deer Park, Eagle Rock, at an elevation of 3,160 feet, provides a panoramic view of the surrounding countryside. During the area's heyday as a summer resort, visitors often traveled here by horse and buggy to take in the view. The sender writes, "My muse is still absent. Rain everyday since Papa left. It may be clear today—if so expect to go to—somewhere."

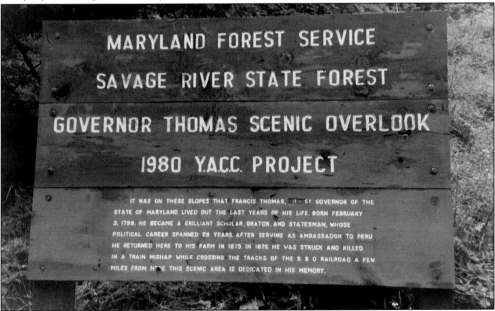

The Governor Thomas Scenic Overlook is located on Savage River Road. Francis Thomas served as governor of Maryland from 1842 until 1845. He spent his retirement years on a farm near here until 1876, when he was struck and killed by a train while crossing the tracks of the B&O Railroad near his home. Thomas died at Frankville, a Garrett County railroading community that had been named in his honor. (Author Photograph.)

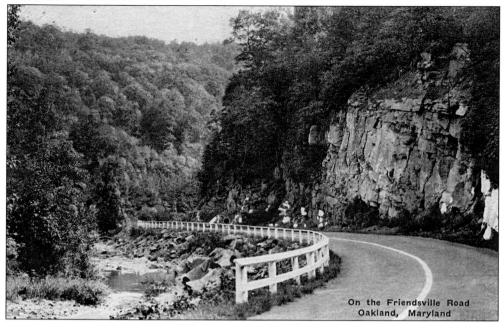

On the Friendsville Road
Oakland, Maryland

Postmarked March 23, 1938, this photograph depicts a scene along the Friendsville Road. The sender writes, "Dear Miss Lula, Thanks for the memories. It was awfully sweet of you to remember my birthday. Thanks a million! Mike."

In March 1971, Garrett Community College consisted of three buildings still under construction on a cleared meadow in McHenry. By September of that same year, the buildings were completed and eight faculty members, covering six courses of study, welcomed the first class of students. The first graduation class, consisting of 27 students, took place on May 19, 1973. In 2002, the institution became known simply as Garrett College. (Ruthvan Morrow Photograph.)

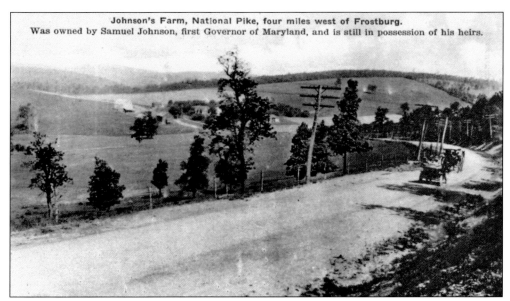

The Johnson Farm was located on the National Road four miles west of Frostburg on the western slope of Little Savage Mountain (elevation 2,817 feet). Through the 19th century and well into the 20th, this land was owned by the Johnson family. Early tax records show that Maryland's first governor under the Maryland Constitution of 1776, Thomas Johnson (not Samuel as the postcard indicates), and his descendants had large land holdings in this region.

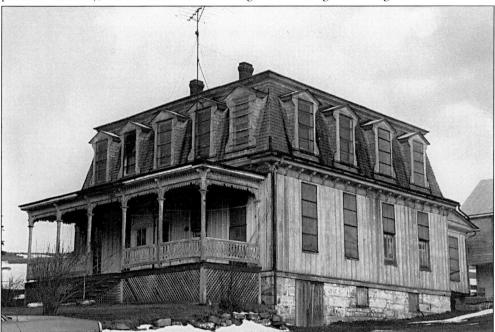

This house, located on the Johnson Farm along U.S. Route 40, the National Road, is believed to have been built sometime between 1872 and 1876. The structure is characterized by its mansard roof, elaborate Victorian trim along the porch and eaves, and vertical board-and-batten siding. At the time of this 1974 photograph, it was one of the finest examples of rural Victorian homes in Garrett County. (Ronald L. Andrews Photograph.)

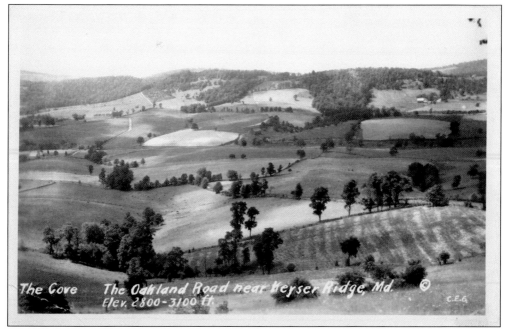

The Cove is along the Oakland Road (Route 219) near Keyser's Ridge. With an elevation of between 2,800 and 3,100 feet, the Cove overlook still presents a panoramic view of one of the finest farming districts in the county. (C. E. Gerkins Photograph.)

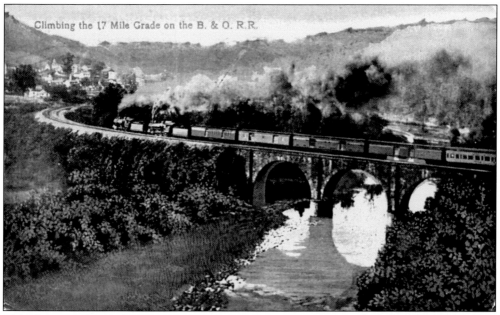

This 1910 view depicts the B&O Railroad's 17-mile grade at the Bloomington viaduct. Beginning at Piedmont, West Virginia, and continuing to Altamont, Maryland, the grade rises 1,626 feet in 17 miles. Construction of the grade took place between 1851 and 1852. The route and grade helped connect the port of Baltimore to the Ohio Valley. The sender writes, "Have been waiting for a letter but I suppose you are still grieving. Hope you got a fortune."

BIBLIOGRAPHY

Broadwater, Maxine Beachy and Matthew W. Novak. *Let My Highway Pictures Lead People . . . The Poetry, Writings, and Photography of Garrett County's Leo Beachy.* vol. II. Oakland, MD: Sincell Publishing.

———. *Stately Halls . . . Photographic Works and Writings of Leo Beachy.* vol. III, Oakland, MD: Sincell Publishing, 1997.

Feldstein, Albert L. *Feldstein's Historic Coal Mining and Railroads of Allegany County.* Cumberland, MD: Commercial Press, 1999.

———. *Feldstein's Historic Garrett County, A Video Postcard Extravaganza.* Cumberland, MD: Commercial Video, 1991.

———. *Feldstein's Revised Historic Postcard Album of Garrett County.* Cumberland, MD: Commercial Press, 1988.

———. *Feldstein's Historic Postcard Album of Garrett County.* Cumberland, MD: Commercial Press, 1984.

Garrett County Historical Society. *Deep Creek Lake, Past and Present.* Parsons, WV: McClain Printing, 1997.

———. *Garrett County 125th Anniversary Photo Album.* Parsons, WV: McClain Printing, 1997.

———. *Ghost Towns of the Upper Potomac.* Parsons, WV: McClain Printing, 1998.

Grant, John. *150 Years of Oakland.* Oakland, MD: Garrett County Historical Society, 1999.

Kline, Benjamin F. G. Jr. *Tall Pines and Winding Rivers: The Logging Railroads of Maryland.* 1976.

Love, Mary I. *Once Upon a Mountaintop: The Improbable History of Mount Lake Park, Maryland.* 1987.

Scharf, John T. *History of Western Maryland.* vol. II. Baltimore: Regional Publishing Company, 1968 (original printing 1882).

Schlosnagle, Stephen. *Garrett County, A History of Maryland's Tableland.* Parsons, WV: McClain Printing, 1978.

Strauss, Mary Miller. *Flowery Vale: A History of Accident, Maryland.* Parsons, WV: McClain Printing, 1986.

Ware, Donna M. *Green Glades and Sooty Gob Piles.* Maryland Historical Trust, 1991.

Weeks, Thekla Fundenberg. *Oakland Centennial History, 1849–1949.* Oakland, MD: Sincell Printing Company, 1949.

DISCOVER THOUSANDS OF LOCAL HISTORY BOOKS
FEATURING MILLIONS OF VINTAGE IMAGES

Arcadia Publishing, the leading local history publisher in the United States, is committed to making history accessible and meaningful through publishing books that celebrate and preserve the heritage of America's people and places.

Find more books like this at
www.arcadiapublishing.com

Search for your hometown history, your old stomping grounds, and even your favorite sports team.

Consistent with our mission to preserve history on a local level, this book was printed in South Carolina on American-made paper and manufactured entirely in the United States. Products carrying the accredited Forest Stewardship Council (FSC) label are printed on 100 percent FSC-certified paper.

MADE IN THE